The Beginner's Guide

Watercolour Landscapes

A complete step-by-step guide to techniques and materials

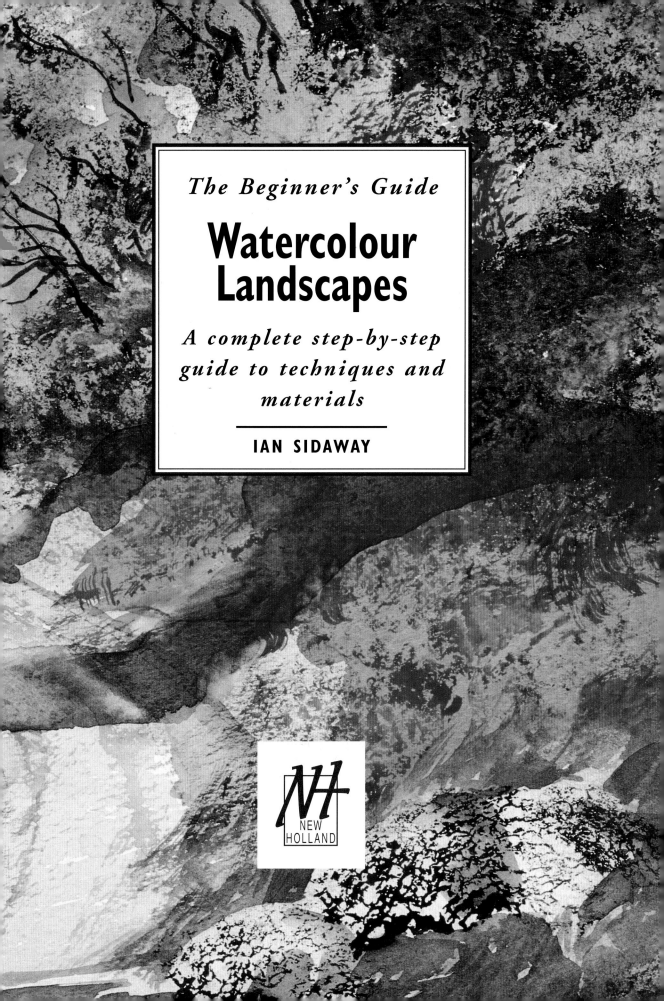

The Beginner's Guide

Watercolour Landscapes

A complete step-by-step guide to techniques and materials

IAN SIDAWAY

NH
NEW HOLLAND

First published in 2001 by
New Holland Publishers (UK) Ltd
London • Cape Town • Sydney • Auckland

Garfield House, 86-88 Edgware Road
London W2 2EA
United Kingdom

80 McKenzie Street
Cape Town 8001
South Africa

Level 1, Unit 4, 14 Aquatic Drive
Frenchs Forest, NSW 2086
Australia

218 Lake Road
Northcote, Auckland
New Zealand

1 3 5 7 9 10 8 6 4 2

ISBN 1 85974 631 4 (hb)
ISBN 1 85974 967 4 (pb)

Designed and edited by
Axis Design Editions Limited
8 Accommodation Road
London NW11 8ED

Managing Editor: Matthew Harvey
Art Director: Siân Keogh
Art Editor: Juliet Brown
Photographer: Mike Good
Senior Editor: Clare Hubbard
Editorial Assistant: Paul McNally
Production: Hazel Kirkman
Editorial Direction: Rosemary Wilkinson

Reproduced in Singapore by Colour Symphony
Printed and Bound in Malaysia by Times Offset (M) Sdn Bhd

ACKNOWLEDGEMENTS
Special thanks are due to Daler-Rowney,
P.O. Box 10, Bracknell, Berkshire RG12 4ST
for providing the materials and equipment featured in this book.

CONTENTS

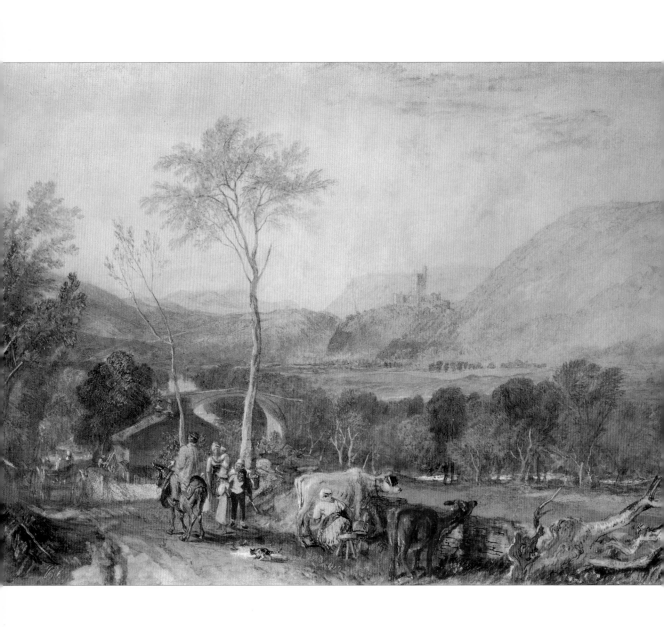

INTRODUCTION

It was in China that the art of painting with brush and watercolour or dilute ink first reached a form that could be described as a fine art. Chinese painting is linked closely with that country's calligraphy; the same materials are used in both, as are many of the brush techniques and visual considerations. Created on silk or paper – both of which were invented in China – many calligraphy works were made as scrolls that were opened and "read" from right to left, a form that perfectly suited landscape subjects.

In Europe the beginnings of the water-colour tradition are more difficult to pin down. Watercolour, or more correctly gouache or body colour, was used to illuminate religious texts and manuscripts. The beginnings of its use in the artist's studio and as a material for painting on a larger scale are not so easily traced. However, it is thought to have first been used by apprentice artists who trained by making tonal drawings using

Hornby castle
Joseph Mallord William Turner 1775–1851

Turner saw watercolour enter its "Golden Age", as can be seen in this beautifully composed landscape using classic light to dark technique.

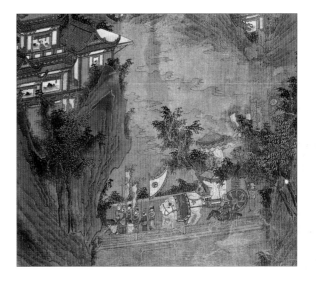

Landscape (detail)
Li Sixun 651–716

This Chinese work on silk already shows a grasp of techniques such as working light to dark.

a brush and a mixture of water and a single brown pigment that was made from beech wood soot, known as *bistre*.

During the 17th century artists began to make more use of the technique and added sepia, a reddish brown pigment made from the inky secretions of cuttle-fish, to the palette. Full-colour paintings using water-based materials were rare before the 18th

century, although the characteristic fluidity of watercolour lends itself perfectly to landscape and the natural world, something that German artist Albrecht Dürer (1471–1528) had recognised some 300 years earlier.

During the 17th century wash drawings began to be made as finished works, rather than as studies for oil paintings. In Antwerp Peter Paul Rubens (1577–1640) executed a number of watercolour landscapes, as did the Dutch painter Anthony Van Dyck (1599–1641). It was Van Dyck who began the tradition of working on location ("*en plien-aire*").

An English Landscape
Anthony Van Dyck 1599–1641

With his economic brushwork, Van Dyck manages to give this coastal scene a freshness that a more studied approach would miss.

With many European artists in the 17th and 18th centuries visiting England, and many English patrons collecting foreign artists' works, it was small wonder that watercolour landscape painting became so popular in England. By 1855 a French critic reviewing an exhibition of English watercolour paintings in Paris wrote: "Watercolour is, for the English, a national art".

Paul Sandby (1725–1809), who worked in the military drawing office at the tower of London, was seen as the "father of English watercolour". A founding member of the Royal Academy in London, Sandby worked exclusively in England, Wales and Scotland. His work had great flair, poetry and sense of place. He was not afraid to experiment, using watercolour both as thin transparent washes and as body colour. His exhibitions in London influenced many younger artists

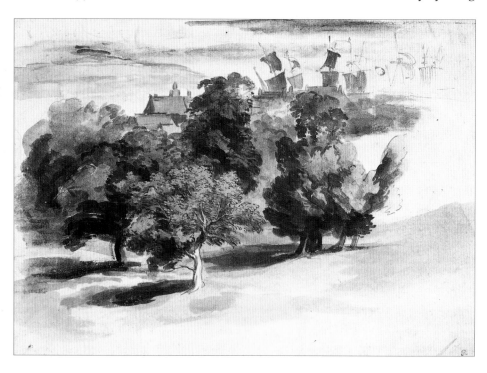

and moved no less an artist than Thomas Gainsborough (1727–1788) to describe him as a genius. Sandby was closely followed by Thomas Girtin (1775–1802) and William Turner (1775–1851). While Girtin died at 27, Turner saw English watercolour landscape painting enter into the 19th century and what was to be called its "Golden Age".

The 1820–30s saw a romantic and mystic view of the landscape emerge in the work of artists such as William Blake (1757–1827) and Samuel Palmer (1805–1881). Two expatriate Americans working in England, James Abbott McNeill Whistler (1834–1903) and John Singer Sargent (1856–1925) pushed the watercolour technique forward in the late 19th century. Across the Atlantic the torch bearer was Winslow Homer (1836–1910). His landscapes of Nassau, in the Bahamas, and Maine are powerful works.

In the early 20th century watercolour found a new set of devotees. These included Englishman Paul Nash (1889–1946), a master interpreter of the rhythm of landscape.

Icknield Way
Paul Nash 1889–1946

Painted in 1935, this work shows Nash's skill at capturing the essence of a landscape, using a limited palette to create a sense of harmony.

The architect Charles Rennie Mackintosh (1868–1928) produced watercolours that are masterpieces of design and contain echoes of art nouveau. While Sir William Russell Flint (1880–1969), showed breathtaking technical ability in his exquisite landscapes.

The last half of the 20th century up to the present day has seen a huge diversity of watercolour work, from the claustrophobic world depicted by American Andrew Wyeth (1917–) to the moody seascapes of the contemporary English artist Len Tabner, and the restful coastal reflections of his compatriot Robert Tilling. The range of vision underlines the versatility of the material, capable as it is of capturing intimate detail and also the grandeur of an intriguing subject.

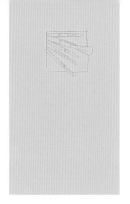

MATERIALS AND EQUIPMENT

Preparation is the key to creating successful watercolours, and choosing good quality materials and equipment is essential. Start off with a few well-chosen basics, and then experiment with different brushes, colours and papers.

PAPER

There are hundreds of watercolour papers from which to choose. Some are easier to work on than others, and each has distinct qualities. By learning a little about their characteristics, you will be able to make an informed choice.

Watercolour paper is either handmade or machine-made. Handmade is more expensive than machine-made, but it is a wonderful surface on which to work. Machine-made paper is made using the same processes, but the sheets are formed on a machine. Though cheaper, it is still good to use and can be the better choice for the beginner.

Watercolour paper is woven: a sheet is formed by coating the mesh surface of a mould with pulp. As the pulp fibres dry, they interlock, giving the sheet its strength. The sheet is then processed to give one of three different surfaces.

Rough Rough paper is made by allowing the felts, dampened cloths placed between the wet sheets as they dry, to leave an imprint on the paper surface. The sheets are not pressed, so the paper texture remains rough. With practice, rough papers can be a good choice for watercolour landscape. Washes can be made to lie flat with consistent strength of colour; it is also possible to create a number of textural effects that give the work vibrancy.

There is an almost dizzying array of papers available. However, once the basic properties of the various types are known, it becomes simple to select the right paper for the job.

Hot Pressed Formed in the same way as rough paper, but laid onto smoother felts, this paper is then pressed between polished steel rollers or plates to remove any surface texture. It is good for drawing and detailed work, but makes washes difficult to control and the finished work may lack depth.

Cold Pressed Cold pressed paper is also known as NOT – for "Not Hot Pressed". The paper receives a moderate pressing but retains a slight texture. Cold pressed paper is the easiest to use; it is smooth enough for detailed work, and has enough texture to allow for lively brush work and textural effects. Colour sits well on the surface and flat washes are easily achieved: this type of paper is the best choice for beginners.

Absorbency Paper is "sized" during manufacture, and the amount and type of "sizing" affects its absorbency. Paper can be internally sized, surface-sized, or both. Internally sized paper allows paint to sink into the fibres. This results in good depth of colour, flat washes are possible, but corrections are difficult. Surface-sized paper absorbs less paint so it is easier to make corrections but flat washes are difficult. Colours may be bright, but lack depth.

Size and Weight Papers are available in a range of sizes. The standard size is 560x760mm (22x30in). Certain brands are available in rolls and large sheets up to 1220x1520mm (48x60in). A paper's weight indicates its thickness, and is described in two ways.

The first is in pounds (lbs) and refers to the weight of a ream (500 sheets of paper). The second is in grams (gsm) and refers to the weight in grams of one square metre of a single sheet. Watercolour paper ranges from around 90lb/200gsm to 400lb/850gsm.

WATERCOLOUR PAINT

Paint is available in semi-moist pans, half pans, tubes and bottles. Bottled colours are strong and vivid, but often fade when subjected to sunlight. Pan colours are easy to use, and enable the artist to mix only a little paint at a time. This allows control of the mixes and is economical. It is easy to use too much tube colour but if a large amount of a wash is needed to cover a large area, tube colour is the better choice.

Choosing a palette of colours to use is a personal choice. However, most artists will use a limited palette from which they can mix a complete

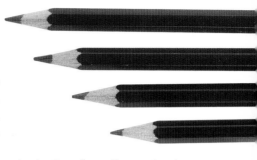

A selection of pencils, varying in hardness. Some artists like their initial sketch to show through in the finished work.

range of colours. The limited palette colours are: cadmium red; alizarin crimson; lemon yellow; yellow ochre; cadmium yellow; cobalt blue; cerulean blue; ultramarine blue; burnt umber; raw umber; viridian; oxide of chromium; sap green and Paynes grey.

As artists gain in skill, they tend to use fewer colours. You can produce a complete spectrum with a remarkably small selection of colours. Below are some standard choices for most artists' palettes.

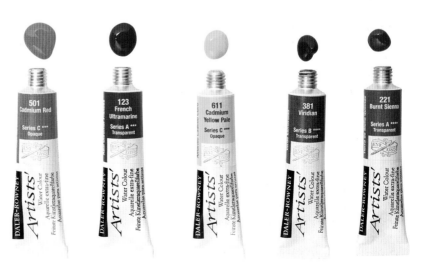

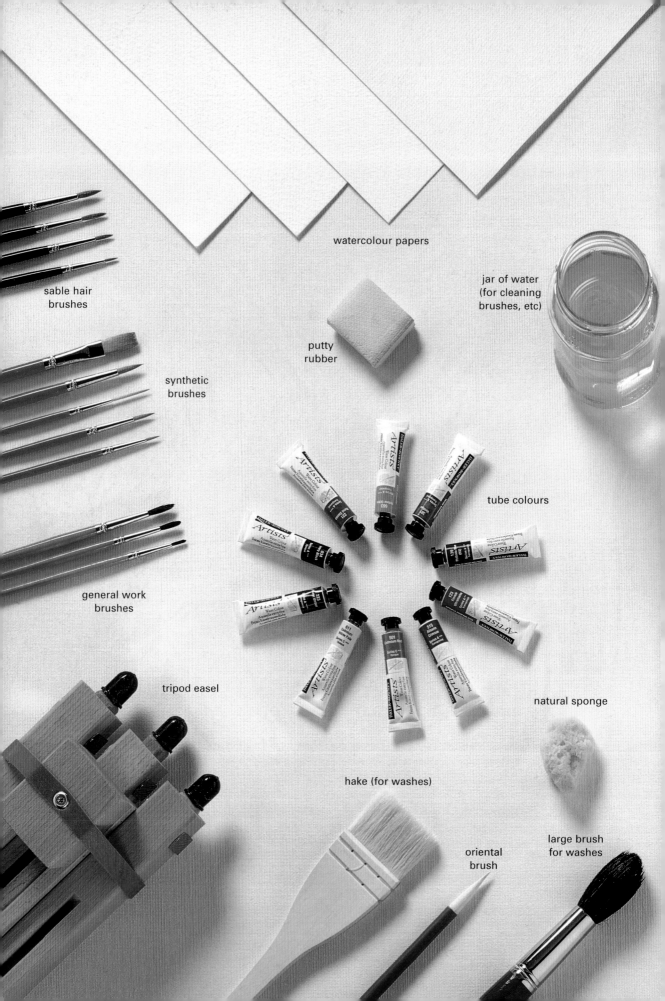

watercolour papers

jar of water
(for cleaning
brushes, etc)

sable hair
brushes

putty
rubber

synthetic
brushes

tube colours

general work
brushes

tripod easel

natural sponge

hake (for washes)

oriental
brush

large brush
for washes

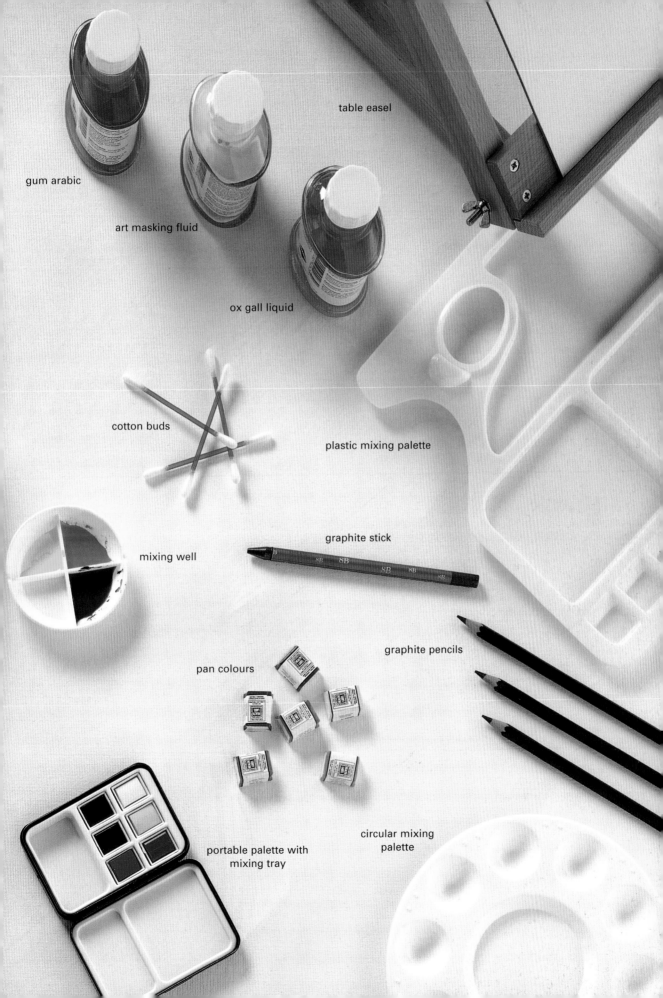

gum arabic

art masking fluid

table easel

ox gall liquid

cotton buds

plastic mixing palette

mixing well

graphite stick

graphite pencils

pan colours

portable palette with
mixing tray

circular mixing
palette

Pan colours are more economical and portable than tube colours. They are sold as cubes of paint.

MEDIUMS & ADDITIVES

Adding mediums and additives to paint alters its behaviour. Gum Arabic, gum water and watercolour medium increase transparency and the brilliance of colours. They also increase the solubility of the paint when it dries, making corrections easy to make by re-wetting the paint.

Ox gall is a wetting agent made from the gall bladder of cattle. Some papers that are heavily sized repel the watercolour washes, making them puddle. A few drops of ox gall lessens the paint's surface tension, making it flow more easily.

Aquapasto and impasto gels are used to add body to watercolour mixes. Texture medium will produce similar effects and can be used to give a layered effect. Blending medium slows the drying time of the watercolour washes and can be very useful when working in the sun or in hot weather.

Granulation medium makes paint granulate, giving it a textured, speckled appearance. Art masking fluid is a liquid rubber solution that resists paint when dry. It is painted onto the work with a brush and then removed when the painting is dry to reveal an unpainted area.

Permanent masking fluid can be used in the same way as art masking fluid but does not need to be removed. Paint can also be added to it, and then when used in the normal way, will repel subsequent washes.

BRUSHES

Brushes for watercolour are made using synthetic polymer, nylon or natural animal hair. The best brushes are made from the tail hair of the sable; they hold a lot of paint and hold their point and shape well. Sable brushes are expensive but if looked after repay the initial expense with years of use. Squirrel, ox, pony and goat hair are used for many larger wash brushes whilst oriental brushes use hair from exotic sources, including wolf.

The most useful brushes are the round, the mop and the flat. These are available in a range of sizes. Round brushes can be used for most jobs, while mop or wash brushes are used for applying washes. Flat brushes can also be used for washes and are easy to control.

Oriental brushes are useful but were intended to be used and held in a different way to brushes made in the West. One

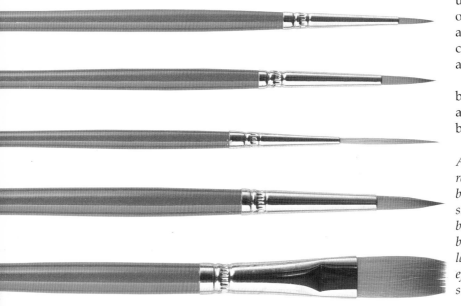

A selection of brushes increases the repertoire of the artist. From top to bottom: a rigger brush for detail; a slightly larger detail brush; a long brush for drawing lines; a medium brush for general work; and a large, flat head brush for painting effective washes. Each artist's style calls for different brushes.

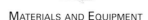

of the most useful is the "hake", this is a flat soft brush which makes an ideal wash brush.

AUXILIARY EQUIPMENT

Drawing boards are needed to stretch paper. Having several boards means that you can stretch several sheets at the same time. You will need a board that will accommodate the largest sheet of paper you are likely to stretch, whilst smaller boards are good for taking with you when working on location. An economical way of making boards is to buy a sheet of medium density fibre (MDF) board and cut it into several boards; this can be done free of charge at DIY stores.

Whilst an easel is by no means vital, it can be beneficial and makes adjusting the angle at which you work easy. Watercolours are invariably worked on flat or at the very most a 40° angle, as otherwise the washes run. Table easels are ideal when working at home since they offer just the right degrees of tilt. If you are working on location you will need an easily transportable easel that will grip your board and paper at the correct angle and is stable enough not to blow over.

You will need one or more palettes in which to mix colours. While palettes inside many watercolour paint boxes are convenient, they are usually too small. A wide range of palettes made from metal, plastic and ceramic are available, each with a different configuration of mixing wells. If you are using large quantities of paint and mixing washes, you will need a palette with deep wells. Old yoghurt pots or tin cans make good mixing wells.

Sponges are useful for painting with, making textures and mopping up paint. Natural sponges have intricate, organic patterns and artists will often collect a few. Finally, keep a roll of paper towel to hand.

Sable brushes are the best-quality brushes available. However, they are expensive and unattractive from an environmental point of view. Synthetic brushes are usually perfectly usable.

It is worth keeping a store of different papers at hand – to create different effects. A desk and tripod easel will also come in handy.

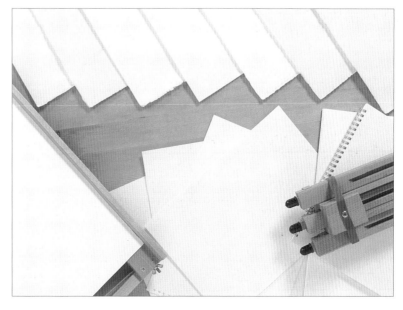

BASIC TECHNIQUES

Spending some time learning and practising the techniques will give you confidence when you come to paint. It will also strengthen your understanding of the medium's capabilities and the creative effects you can achieve with it.

Having a sound knowledge of the basic techniques is more important when you are using watercolour than when using any other medium. Watercolour has a reputation for being difficult and unpredictable. This is not unfounded; it can sometimes seem to have a mind of its own, which can lead the artist to frustration. Unlike oil and acrylic paint and any of the dry art materials, watercolour does not always stay where it is put. Using wet on dry washes is on the whole controllable but when working wet into wet, making a graded or variegated wash, or when using techniques such as masking or granulation, the paint does not always do quite what was intended.

It is with practice and experience that the watercolour artist learns how to look ahead and take advantage of those chance effects that are a characteristic of watercolours, and are part of the real charm and attraction of this medium.

MIXING PAINT

When using the traditional transparent watercolour technique, no white paint is used. Paintings are made on white paper. A colour is made lighter in tone by adding more water. This thins the colour so that when it is applied to the paper in the form of a wash, it absorbs very little light and so allows a high degree of light to reflect back off the white paper surface through the layer of paint.

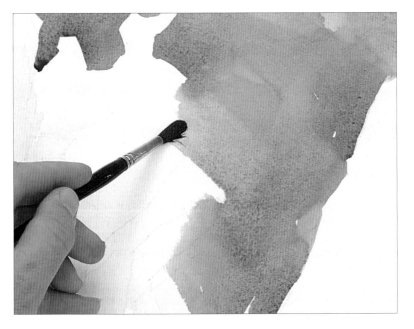

It is important to know how to fill a large area with the same colour. The artist can then add darker or lighter areas to create depth and texture.

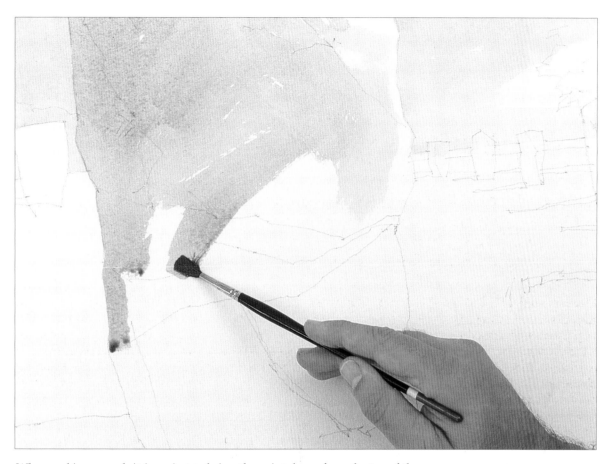

When making a wash it is easiest to bring the paint down from the top of the paper.

A colour can be made darker or more intense by adding more pigment. When this is applied to the paper, it absorbs more light and allows less light to reflect back to the viewer.

BASIC WASH TECHNIQUE

The manipulation and organization of semi-transparent washes is central to good watercolour technique. The ideal is to lay a perfectly flat wash over a sizeable area. In reality a completely flat wash is rarely if ever used, other than when you need to paint a wide expanse of colour, such as a clear blue sky. Even then nuances or brush marks or a change in colour intensity should not be considered as something imperfect or bad. Indeed being able to accommodate and utilize the occasionally fickle behaviour of the paint into the work is all part of good watercolour technique. When it works to the artist's advantage, this has become known as the "happy accident" and is something that experienced watercolour artists incorporate into their work all the time.

You will find that it helps to take a few minutes to prepare your work area prior to beginning your painting. If you are left-handed arrange your paints, palettes and brushes to the left of your support; if you are right-handed arrange everything to the right. This will help to prevent many of the spills, smudges and blots that can happen when you are painting the picture. Try to have two jars of water to hand: one for mixing, and the other for cleaning your brushes. The water can become dirty very quickly and nothing

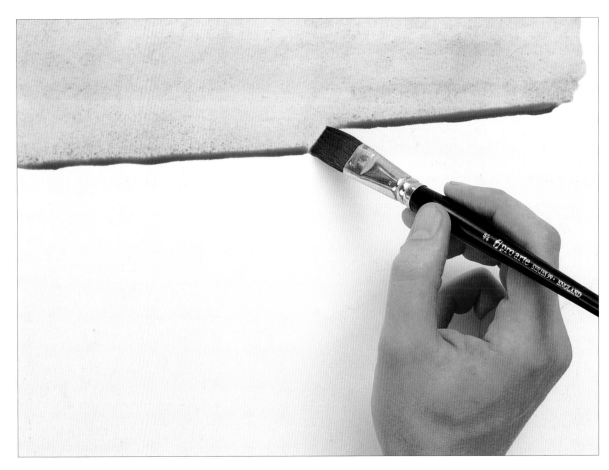

is guaranteed to make your colours look muddy and subdued more than using dirty water. Make sure that you have enough palettes and containers ready to make your mixes in, and always have plenty of paper towels to hand for clearing up those previously mentioned spills and blots, and for making any corrections on the paper.

FLAT WASH

Whilst being able to lay a flat wash is not always necessary, learning to lay a flat wash is good practice. A flat wash is one where a consistent colour or tone covers a sizeable area. In order to be successful, it needs to be carried out methodically, reasonably quickly and in one go. Mix up plenty of the required colour before you start. Running out halfway through will mean having to mix more. This causes two problems: first, you will find it almost impossible to mix exactly the same tone of colour, and second, the laid wash will start to dry while you are mixing the new colour, which means a mark will result at the point where the work has been resumed.

Choose a large enough brush, which suits the size of the area to be covered and

Flat washes are useful for learning the behaviour of watercolour paint.

which you can easily manipulate. Remember that a very large brush may hold too much paint, which could result in runs.

First place your support at a slight angle of around 20°. Some artists like to dampen the area to receive the wash first, using a sponge. This is not necessary, but you may like to experiment with both dry and damp surfaces to see which suits you best. Load the brush with paint and make a steady horizontal

18

Stretching Watercolour Paper

When a sheet of watercolour paper is wet, the paper fibres swell and the sheet becomes marginally larger, which causes it to buckle. As the sheet dries and shrinks the uneven buckled surface often remains. This makes applying subsequent washes difficult, since the paint collects and puddles in the "valleys". The answer is to stretch the paper onto a drawing board. This forces it to dry flat and tight each time it dries. All papers can be stretched but heavier weight papers of 640gsm/300lb and more tend to stay flat without stretching as their inherent thickness prevents buckling. In order to stretch your paper you will need: a sheet of your chosen paper cut to the size you intend to work, a wooden drawing board that is larger than the sheet of paper being used, gummed paper tape, scissors, a sponge and clean water.

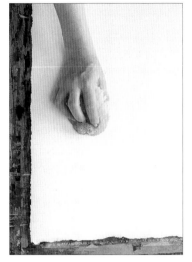

1

Working on a flat surface, place the sheet of watercolour paper onto the centre of the board. Cut four lengths of gummed tape, one for each side of the paper. Using the sponge, wet the paper thoroughly with water. The thicker the sheet, the more water it will need. Some books recommend soaking the paper in a bath, with thicker handmade papers being soaked for prolonged periods of time and then transferred to the board. This is rarely necessary and sponges are fine for all but the thickest of papers. Remove excess water with the sponge.

2

At this point you will need to work quickly as the paper will begin to curl and buckle. If the paper is very thin the degree of curling can be alarming. Wet one length of paper tape using the sponge and apply it along one edge of the paper so that one-third sticks to the paper with the remaining two-thirds sticking to the board. Smooth the tape down using the sponge. If the paper is curling, smooth it out and apply the tape to the other three edges in the same way. If the paper is only marginally smaller than the drawing board, smooth the tape over its edge.

3

The paper may not look flat at this stage, but resist the temptation to fiddle with it. Place the board to one side and let it dry. Drying time depends on how wet and how thick the sheet of paper was, but if you are working in room temperature, most papers should be sufficiently dry in one or two hours. The drying can be speeded up by using a hair dryer. To ensure that the sheet dries in an even manner the dryer must be kept moving, and you need to take care not to allow the dryer to come too close. To remove the painting once it has been completed, use a sharp knife to cut around the edge where the paper tape joins the board.

stroke across the top of the paper or area of paper that is to receive the wash.

Once the stroke has been made, notice how the tilt of the board has made the paint collect or puddle along the bottom of the stroke. Refill your brush and make another horizontal stroke in the same direction, slightly overlapping the first. This collects up the puddled paint, which runs down and collects at the bottom of the second stroke.

Repeat the process until the area is covered. Collect any paint that puddles at the bottom of the painted area by carefully touching it with a dry brush or paper towel. Leave the support at the same angle while the wash dries naturally.

Right: Washes are used here early in the picture to build up areas of colour.

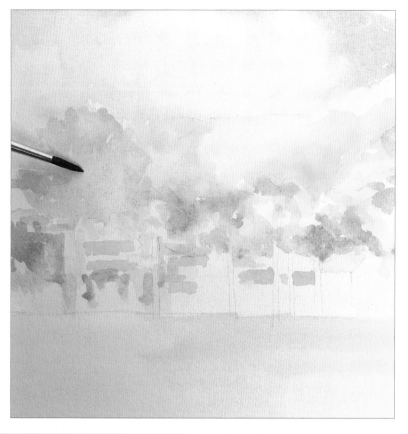

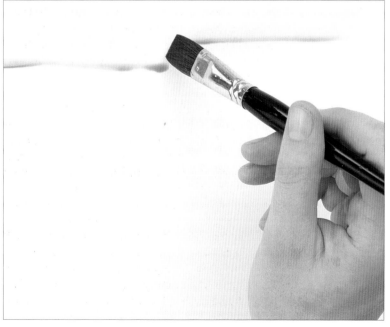

Left: In this graded wash, the paint gradually gets lighter.

GRADED WASH

A graded wash is one where the tone of the colour changes over the area, becoming either lighter or darker. A graded wash is made in precisely the same way as a flat wash. The gradation of colour is achieved by adding more water to the wash mix after each one or several horizontal strokes of the brush, so making the colour become gradually lighter down the paper.

Mastering this technique may take some practice. It is a little more difficult to achieve

than an ordinary wash as water-colour washes behave and dry at different rates according to how much water or pigment they contain. A variation on the graded wash technique is to use a sponge to wet the lighter portion of the area and bring the wash down into it.

VARIEGATED WASH

The variegated wash has one colour blending into another. It is made in the same way as other washes, but at some point a second colour is introduced. Mix up plenty of both colours before you start and have two brushes, one for each colour. You need to choose the colours carefully because some become muddy and dull when they are mixed together. Begin working as before and when you want to make the transition from one colour to the next, simply switch brushes and colours and carry on. The result may not be a perfect seamless transition but that doesn't matter. Again, you may find the process is easier if you dampen the paper beforehand, using a sponge and water.

GRANULATED WASH

Certain pigments used in watercolour paint are relatively coarse and tend to separate out when mixed together. As the paint dries this leaves a speckled or granular effect, which for the landscape artist can be very useful. The paint mixtures that work best are the earth colours, which include, burnt umber, raw umber and raw sienna, combined with any blue.

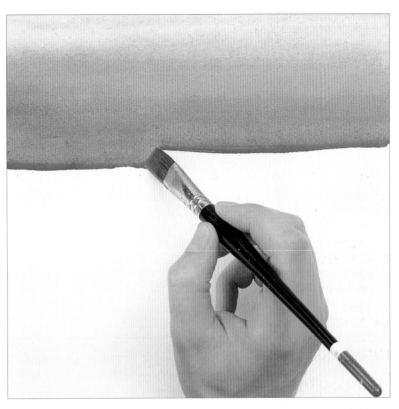

Certain combinations work better than others and the effect works to a greater or lesser extent depending on the surface texture of the paper used. You can also use special granulation medium which can be mixed into watercolour washes. The more of the medium that is mixed into the wash, the greater the degree of granulation that appears as the paint dries.

Watercolour paint is applied to either a dry or a wet surface and each results in the paint behaving and drying in a distinctly different way. These techniques are known as "wet on dry" and "wet on wet" and can be used either on their own or in combination with one another in the confines of one painting.

A variegated wash, in which blue has been run into red. This technique is particularly effective for painting the subtle changes of colour in a sunrise or sunset. It takes a bit of practice to perfect.

WET ON DRY

When a wash or watercolour mark is made onto a dry surface the paint usually stays where it is put, unless the paper being used does not contain much size and is particularly absorbent. The edge quality of the mark will be crisp and the colour will remain pretty much the same as was mixed, becoming only slightly lighter as it dries. The wet on dry technique allows for sharp focus and detail.

Working wet on wet for a sky area.

MASKING

There are various other techniques that can be employed by the watercolour artist to achieve different effects. One such is masking. This is the practice of using an agent to repel paint – thus preserving white areas of the paper. There are various substances that can be used. The most common is commercially produced masking fluid which is much more controllable than substances such as wax, with the added benefit that it can be easily removed.

ROCK SALT

It can be quite difficult to achieve textural effects with watercolour paint. Artists have therefore devised a number of

WET ON WET

When a watercolour wash or mark is made onto a wet or damp surface, the paint spreads and bleeds in all directions. Depending on the dampness of the support this can be difficult to control, particularly for the beginner. The wet on wet technique results in colours mixing together to create some beautiful effects when dry. The paint will dry with a mixture of soft edges and harder water or drying marks where very wet paint has pushed against paint that is not so wet and then taken longer to dry. This technique is the one you should use when trying to capture atmospheric skies, mists or perhaps swirling water or wet sand.

Painting removable masking fluid onto paper.

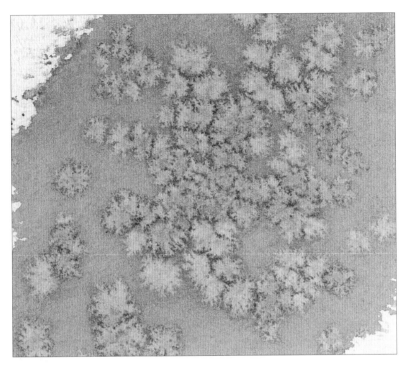

SPATTERING

Another method for texturing otherwise flat areas of colour is spattering. This involves using the brush to flick paint onto the paper. A toothbrush is especially useful for spattering, allowing for more control over the direction of the paint. Spattering helps to create a speckled appearance, and is used for waves crashing on the shore and rough surface effects.

Spattering is another technique that creates interesting textures in a painting. By levering back the bristles, the artist effectively catapults paint at the page. It need not be hit-and-miss though. Cover areas you do not want to spatter.

The dappled effect caused by sprinkling salt crystals onto wet paint. Each crystal sucks up the paint immediately surrounding it, making a roughly circular, star-like impression. The absorbency of the paper alters its effectiveness.

"cheats" that can be used to add texture to a picture. One of these is the use of rock salt. When rock salt crystals are sprinkled onto a still-wet area of paint, they immediately start to absorb the paint. When the paint is dry, the salt is removed leaving a dappled effect. This technique is particularly useful for creating rocky or rough watery areas with watercolour paint.

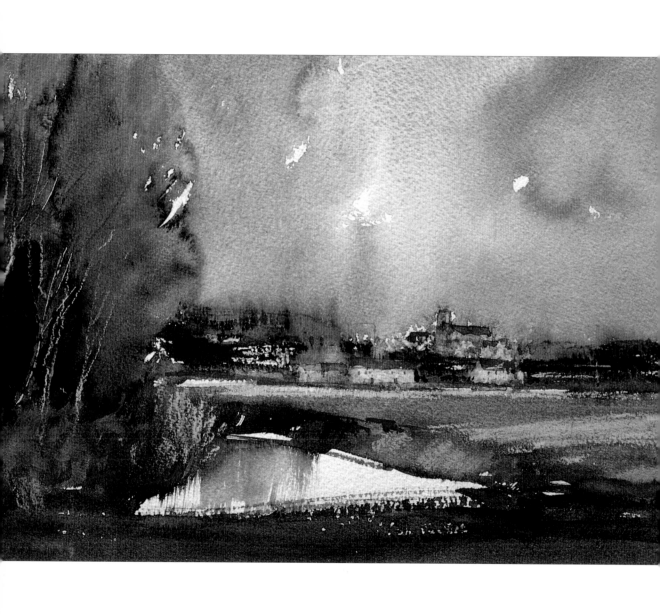

GALLERY

Once a few basic skills have been mastered, watercolour can be used to achieve a range of effects. The water-colour landscapes by contemporary artists on the following pages demonstrate just some of the many different effects that artists can produce using a limited arsenal of painting techniques. Watercolour can be used for shadowy, atmospheric scenes in the depths of wooded areas as well as bright, buoyant landscapes dominated by blue skies.

The key to working in watercolour, demonstrated in the work that follows, is to know basically what you are going to do before you start, and not to overwork the paper. Watercolour landscapes invariably benefit from lightness of touch – a quality that develops with the skill of the artist.

Cley Village
Alan Oliver
30 x 40cm (12 x 16in)

Wet into wet washes dry to leave interesting watermarks that read as the foliage of trees and rain falling across the horizon. The fluid brush strokes pick up the texture of the rough paper, adding a certain crispness to the paint work, while the restrained use of a little soft pastel adds colour to the work.

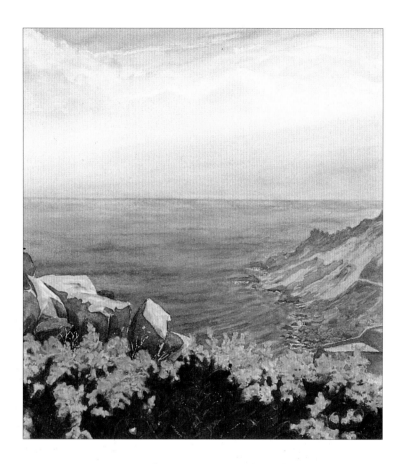

Lamorna
Annette Johnson
35 x 55cm (14 x 22in)

This picture of the Cornish coast in southern England uses predominantly cool colours and an unusual composition, resulting in a an almost palpable sense of space. The crisp detail on the rocks and the yellow flowers create a barrier over which the viewer peers down into the bay below.

Peter's Island
Shirley Felts
40 x 55cm (16 x 22in)

The surface texture of the paper is exploited beautifully here to give an uneven-edge quality to the brush work. This is consistent with the effects of the leaves and the multi-layered, thick and almost impenetrable undergrowth of this scene in Guyana, South America.

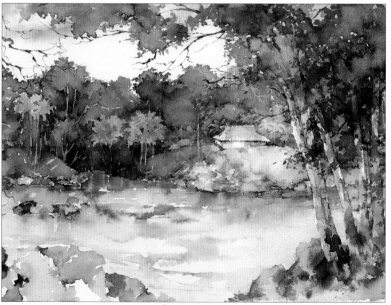

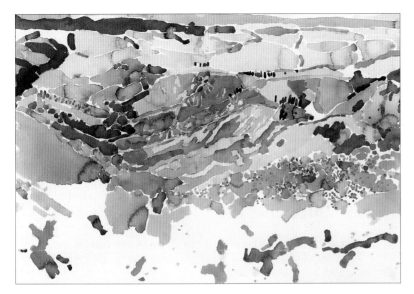

The Balze, Volterra

Katy Ellis
45 x 60cm (18 x 24in)

A patchwork of colours are applied predominantly wet on dry over and next to one another. They link together like a jigsaw to represent a sweeping Italian vista of trees interspersed with rocky outcrops.

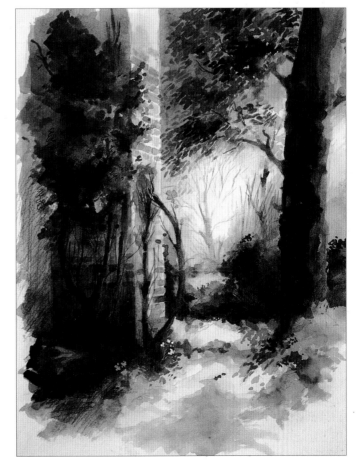

Early Morning at the Dell

John Lidzey
40 x 30cm (16 x 12in)

Early morning sunlight creates a tunnel through the trees that pulls the viewer into this picture, while the small jewel-like patch of blue flowers in the foreground pulls the eye back again.

Garden Ruins, Gunnersbury

Roger Hutchins
40 x 30cm (16 x 12in)

The effects of dappled light
and shade are achieved here
by the clever use of layering
wet paint on dry. The
shadows are painted in with
cooler blues and greys over
the warmer reds and
browns of the brickwork.

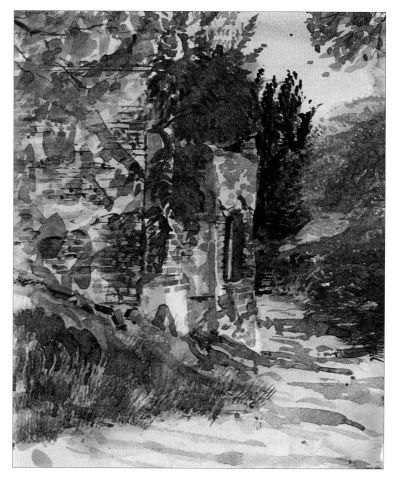

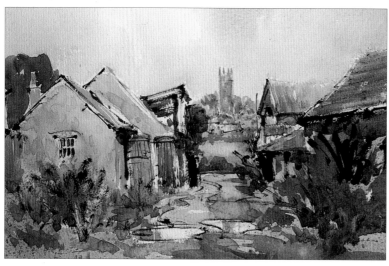

Abandoned Farmyard

Alan Oliver
30 x 40cm (12 x 16in)

A very real sense of distance
is achieved by using a
combination of linear and
aerial perspective. Black
paint is used effectively
to add definition and detail
to the foreground.

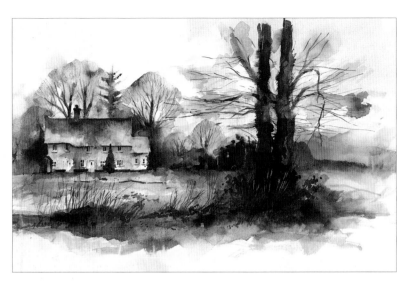

Cottage at Yaxley

John Lidzey
20 x 40cm (8 x 16in)

The rich colours of late autumn are created here using a combination of yellow and orange, while the coolness of the day is suggested by cool blues and greys. Note how the fine twigs and branches are pulled out when the paint is wet from the dark tree trunk standing in the foreground.

The Old Monastery, Majorca

David Curtis
45 x 65cm (18 x 26in)

Here a mixture of dry brush and wet on wet work recreates a mountain scene. The painting captures the sunlight striking the buildings and people of the village. The artist uses fainter colours to paint the mountains in the distance, creating a great sense of three-dimensional space.

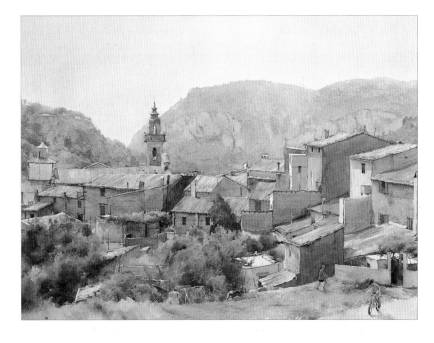

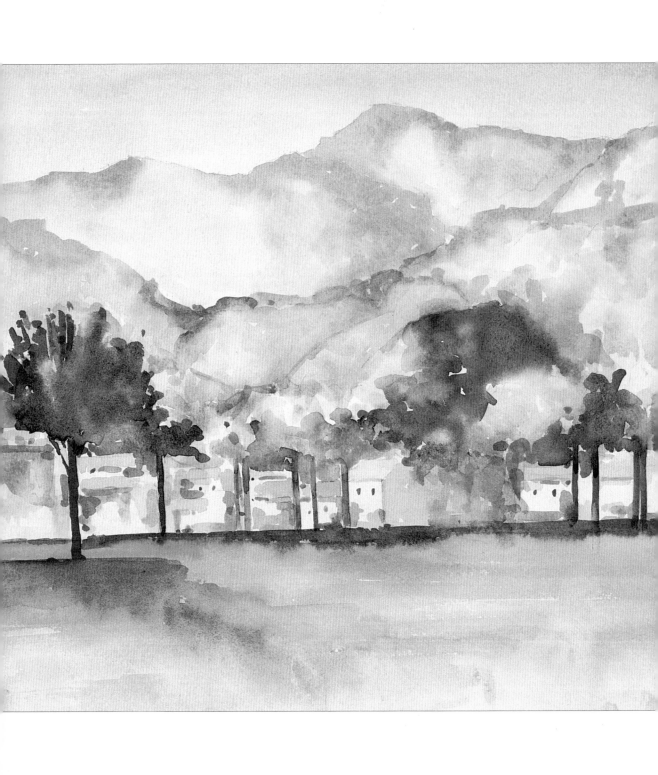

LIGHT TO DARK

Traditional watercolour painting involves building up washes of colour on a white background. An artist will usually work from light to dark, gradually applying darker washes as the painting progresses. This technique is perfect for creating the sense of distance many landscapes require. In this work, the distant hills are washed in at the beginning of the painting and are then left largely unmodified. Stronger colours applied below the hills bring the mid- and foreground closer to the viewer. In the finished picture, the eye is swept back over the field in the foreground, through the woods and the village, and then up into the mountains in the distance.

Barry Freeman
Minorcan Village
40 x 60cm (16 x 24in)

Light to Dark Technique

The darkness of the tone of a colour is governed by the amount of water added. A wash that contains a lot of pigment and relatively little water will be dark and intense, while a wash that contains little pigment and a lot of water will be pale in tone and colour. In areas where a pale wash has been applied a high proportion of the light that falls on the paper is reflected back through the wash. In areas where a dark wash has been used much of the light is absorbed with less reflecting back. Working darker colours over lighter ones means that paintings need to be planned so that the washes proceed in the right order. Before you start a painting, work out the stages into which your painting will be divided.

MINORCAN VILLAGE

Materials and Equipment

- SHEET OF NOT, 600 GSM WATERCOLOUR PAPER, STRETCHED (SEE P. 19)
- 2B PENCIL • ¾IN FLAT BRUSH, MEDIUM-SIZE SOFT HAIR BRUSH
- WATERCOLOUR PAINTS: CERULEAN BLUE, ULTRAMARINE BLUE, ALIZARIN CRIMSON, LIGHT RED, CADMIUM YELLOW, YELLOW OCHRE, VIRIDIAN GREEN
- KITCHEN PAPER TO CATCH MISTAKES

1. Make a light pencil sketch, marking the principal areas of the scene: the foreground field, the trees, the buildings and the mountains. Using a ¾in flat brush damp the surface down. Apply the first pale wash: ultramarine blue for the sky and distant mountains, light red for the closer ones. Mix some alizarin crimson into the light red as you come forward. For the foreground use yellow ochre, mixing alizarin crimson into the mix to add warmth for the near left-hand corner.

2. When the previous wash is dry, mix some cerulean blue, ultramarine blue, cadmium yellow and alizarin crimson. Apply this wash to the most distant hill. Add some more alizarin crimson and light red for the closer hills. Use a wash of viridian green and cadmium yellow for the tree foliage. Use more of the same wash for the area in front of the trees and the village. Take care to leave the houses white at this stage. Also try to keep the edges of the washes soft. Running a slightly damp brush along the edge of a wash areas will usually break up any sharp lines that may have formed.

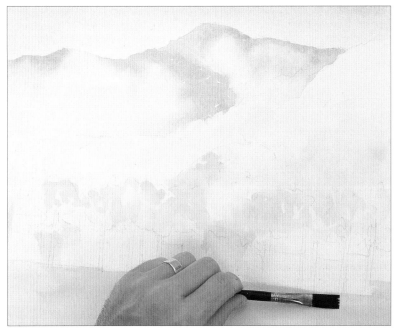

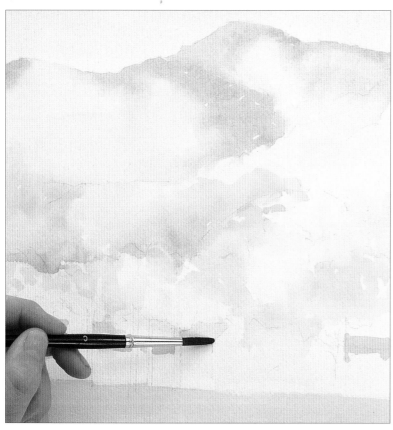

3.

Paint the roof tops with a light red, alizarin crimson and cadmium yellow wash. Mix light red, ultramarine blue and alizarin crimson for the warm areas on the hills. Use pure alizarin crimson for the hillside on the right and pure yellow ochre for the hill on the left.

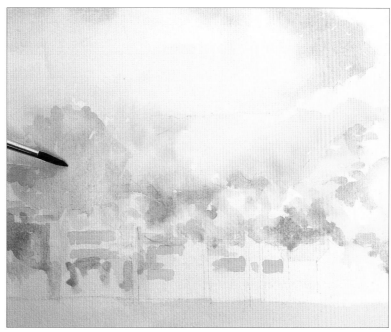

4.

Use a cerulean blue and cadmium yellow wash for the darker foliage areas in the trees. Apply pure cerulean blue to contrast with the red of the roofs.

5.

Mix cerulean blue and yellow ochre for the dark green field areas on the top of the right-hand hill. Use alizarin crimson and viridian green for a dark wash onto the left-hand hills. Make two separate washes for the foreground area. Alizarin crimson and light red, and then yellow ochre and light red. Apply the red mix to the left side of the foreground and the dark orange one to the right – keep them wet and allow the two to merge in the centre. Mark the dark tree trunk and shadow with ultramarine blue, light red and a little viridian green.

6.

Now add some shadows to the main wooded area with ultramarine blue, cerulean blue and alizarin crimson. Mark in the windows of the houses and the trunks of the trees. Use ultramarine blue and alizarin crimson for the shadow under the tree on the left, and viridian green for the foliage.

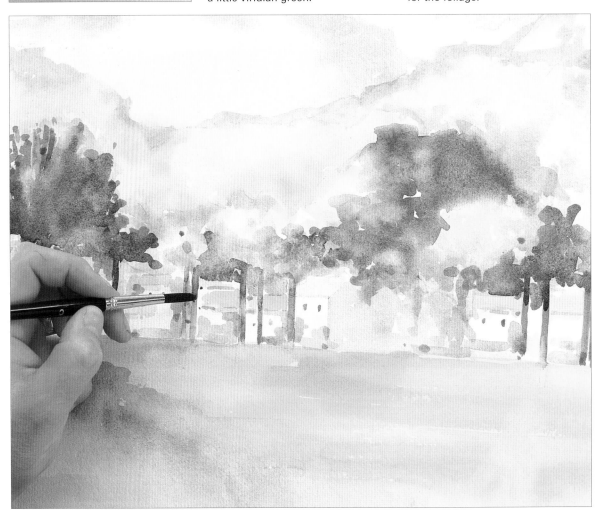

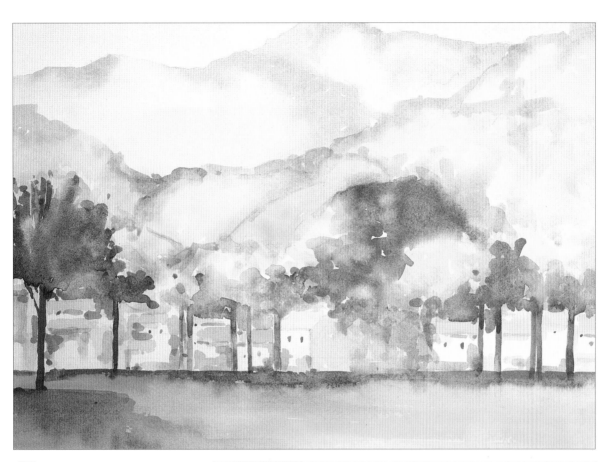

7.

Make a strong wash of viridian green, ultramarine blue and light red for the shadow area in front of the trees and the houses. Use this to darken some of the tree trunks on the right end of the wood, bringing them forward in the picture.

8.

Finish the painting by adding some more definition to the hills in the middle distance with a wash of cerulean blue, a little alizarin crimson, some cadmium yellow and a touch of yellow ochre. Now apply some cerulean blue to the furthest hillside. This last application of paint should push the hill back rather than bring it forward.

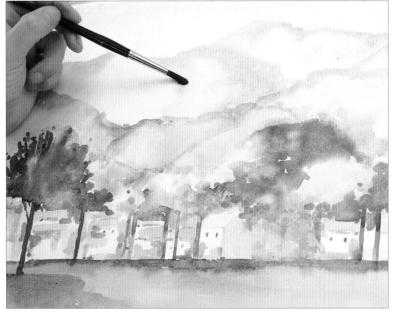

USING WHITE AREAS

The best way to create white areas in a painting is to use the white of the underlying paper. This may sound simple, but in practice, unless the white area is an important part of the picture, it can be only too easy to overlook it until it is too late. Therefore the white areas should be the very first parts of the painting that you consider (in line with the rule of working from light to dark).

In landscape, white is used with surprising frequency. It is needed when painting clouds, crashing surf or waves on the sea, dappled or direct sunlight on water or leaves, reflections, highlights, white buildings in hot countries and snow in cold ones. There are several tried and tested techniques for preserving white areas, including masking and wax resist, both of which we will encounter later on. For now we concentrate on simply painting around them.

Barry Freeman
The Rookery, South London
40 x 60cm (16 x 24in)

Using White Areas Technique

Planning is the key to using white areas. You have to know which areas you wish to leave blank before you apply any paint. Although you are not physically applying paint to the white areas, try to imagine that you are. Think of them as coloured areas rather than just blank paper – as positive shapes rather than negative. They are an important and integral part of your painting and must be considered as such. The first washes you make on the work are very important. If you have planned the painting carefully, these initial washes will delineate the white areas prior to using progressively darker washes. Also bear in mind that should you make a mistake it is easier to make any corrections at this early stage.

THE ROOKERY

1.

Having sketched the basic outlines in pencil, mix a weak wash of cadmium red, cerulean blue and ultramarine blue. Apply this to the sky area, leaving blank areas for clouds. Now mix yellow ochre and light red for the middle distance, leaving white areas for the houses.

2.

Start adding areas of colour into the middle distance. First use a mix of yellow ochre with a little crimson. Now add light red and cerulean blue into the mix for some different tones. Create some darker areas in the middle distance with a mix of cerulean blue, light red and ultramarine blue. To add some warmer touches, mix in light red and more ultramarine. Now start on the trees using a small brush. First mix light red and cerulean blue for a browny-grey colour. Use this for all the trees – starting at the base and working up into the branches.

3.

Add viridian to the mix for darker areas on the trunks. Save some of this for later. Add in light red for the foreground trees. Now paint small areas of pure yellow ochre, pure light red and pure viridian into the trees in the foreground. Use some of the viridian mix saved from earlier to paint the two trees on the far right of the picture.

4.

Mix light red and ultramarine for the area left of centre in the middle distance, and then cobalt for the darker areas. Add texture to the foreground trees with ultramarine, light red and viridian. Use cadmium yellow for the foreground.

5.

Add viridian for the green areas in the foreground, then light red for another tone. Mix in ultramarine for the darker areas. Now make a dark green with cobalt blue, viridian, cerulean blue and light red. Use this for the dark areas on the right side of the middle distance.

6.

Mark in the dark tree trunks with a mix of ultramarine, crimson and cadmium red. Now mix yellow ochre and light red for the base of the foreground trees. Add viridian to this for the foreground greenery. Mix ultramarine and cadmium yellow for the dark ivy. Finally touch in the fine twigs and branches.

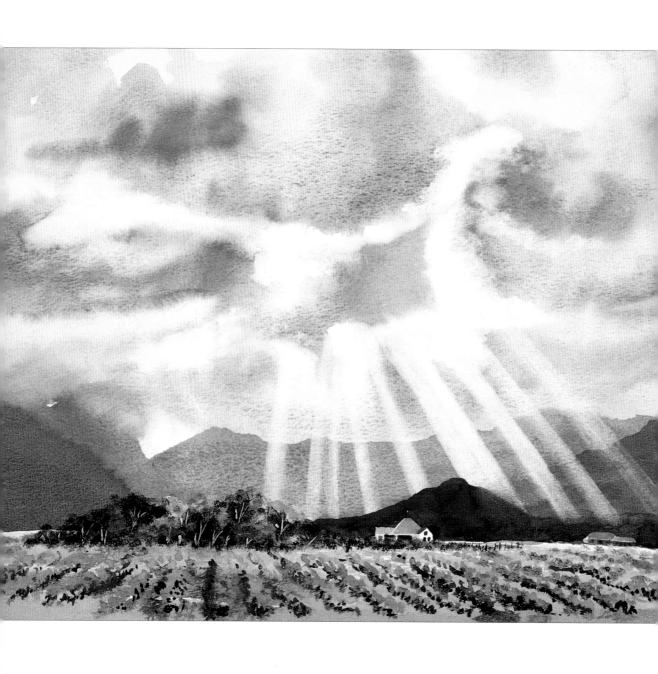

Technique

3

LIFTING OUT

There are rare moments when landscape, sky and light combine to create a truly dramatic scene. In this painting the artist uses a technique called "lifting out" to create rays of light breaking through the cloudy sky and pouring onto the earth. The sky itself was created using wet on wet painting, taking full advantage of watercolour paint's tendency to blend and merge with other wet areas. This can of course be the bane of many a watercolour artist, but, when controlled, it can also be used to great artistic effect. The calm of the house and the vineyard in the midst of the breathtaking land- and skyscape contributes to the overall impact of the work.

Roger Hutchins
The Vineyard
30 x 40cm (12 x 16in)

Lifting Out Technique

Although it is not as flexible as oil paint, water-colour paint can be removed from the paper once it has been applied. The simplest way of doing this is with absorbent materials such as blotting paper, tissue paper, kitchen paper, rags or cotton wool buds. These can be used to lift out newly applied paint that is still damp. This technique is perfect for catching mistakes and unwelcome runs of colour. It can also be used creatively, for example to lift out areas of sky for white clouds. Paint may also be removed once it has dried. This entails using a clean damp brush to dissolve the paint once more, and then an absorbent material to lift the paint out. Both these techniques are more effective on less absorbent papers.

THE VINEYARD

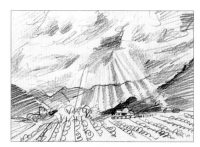

Left: The artist used this quick sketch of a South African vineyard as reference for the painting.

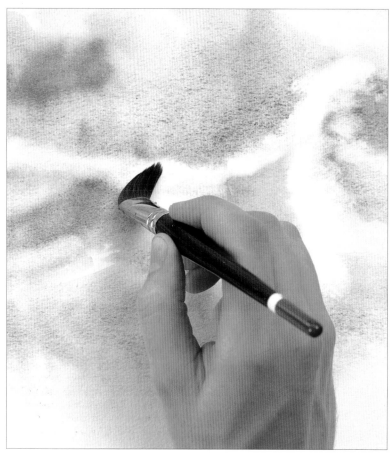

Materials and Equipment

• SHEET OF ROUGH, 300 GSM WATERCOLOUR PAPER, STRETCHED (SEE P. 19) • FLAT SOFT HAIR BRUSHES: ¼IN, ¾IN AND ⅝IN • NO.2 RIGGER BRUSH • ZERO BRUSH FOR DETAIL • NO.4 HOG BRISTLE BRUSH • MEDIUM SOFT HAIR BRUSH • WATERCOLOUR PAINTS: CERULEAN BLUE, ULTRAMARINE BLUE, INDIGO, RAW SIENNA, ALIZARIN CRIMSON, INDIAN RED, GAMBOUGE YELLOW, SEPIA, SAP GREEN, VIRIDIAN GREEN • KITCHEN PAPER TO CATCH MISTAKES

1.

Using a large flat brush, cover the paper with a thin wash of raw sienna. Blot out an area where the break in the clouds will be with kitchen paper. While the wash is still damp, add other colours to the sky; first cerulean blue for the break in the clouds. Now add some darker colours, ultramarine blue, alizarin crimson and Indian red. Allow the colours to run into each other a little. Add touches of indigo to mark dark areas in the cloud. Use a clean damp brush to create lighter areas, washing out the colour and dabbing it off with kitchen paper.

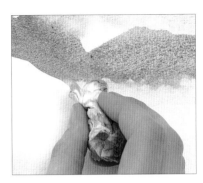

2.

Now start on the hills by giving the area a wash of ultramarine blue and alizarin crimson. Dab away the paint with kitchen paper where the trees are to go.

3.

Use gambouge yellow for the foreground. Mix indigo with ultramarine and Indian red for the closer hills. Use a clean damp hog bristle brush to lift paint for the rays of sunlight. Dab off the moisture with kitchen paper.

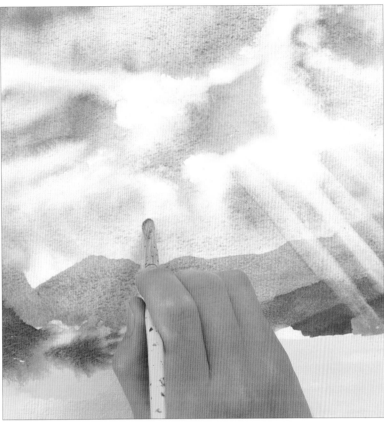

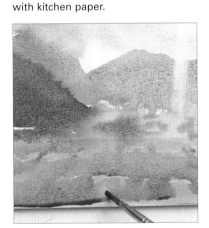

4.

With a ¼in brush add sap green mixed with gambouge yellow for the foreground foliage. Now mix raw sienna and Indian red to establish the lines of the vineyard. The paint should merge slightly.

5.

Use sepia mixed with indigo to add shadow areas to the foreground plants. Mix indigo, Indian red and a little ultramarine blue wash for the near hillside. Be sure to leave blank areas outlining the buildings. Now use the same colour but a smaller brush to add some shadows to the buildings. Build the trees up with neat viridian green. Use the end of the brush to mark the trunks of the trees. Finally, use a zero brush to add detail to the buildings, and use alizarin crimson mixed with viridian and ultramarine blue around the buildings.

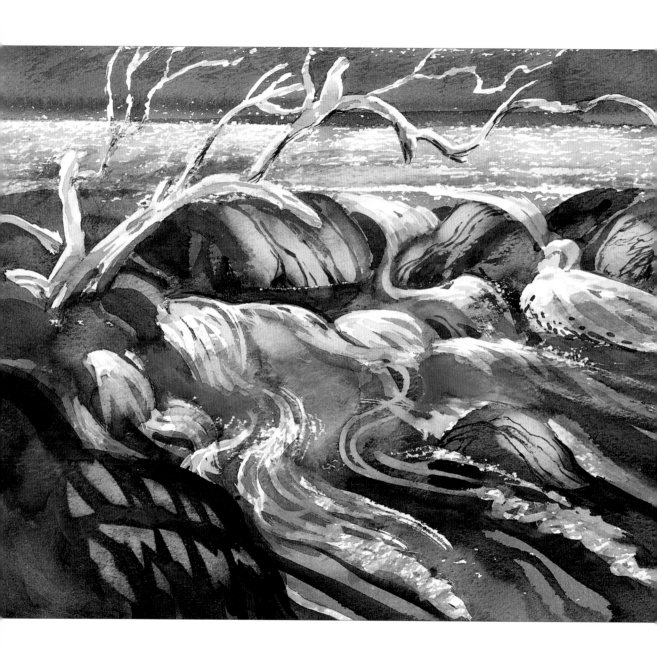

Technique

4

M A S K I N G

Here the artist has used two different methods of masking to create water effects. First he uses art masking fluid to achieve the swirling white surf of the water as it plunges down the rapids. Then he uses a purpose-made stencil to lift out sharp-edged areas on a foreground rock and portray glistening moisture. The first technique needs to be thought out right at the beginning of the painting, as the masking fluid has to be applied early on. The second technique can be carried out at the last moment, as it involves lifting paint off rather than keeping the area white all along. Both serve here to convey the movement and texture of this wild scene.

John Barber
Welsh River Scene
30 x 40cm (12 x 16in)

Masking Technique

There are numerous methods for masking areas so that they will show a previous wash or the white of the paper in the finished painting. Art masking fluid is a rubber solution that is painted onto the paper. Washes can then be laid over it. When the masking fluid is finally removed (rubbed off by hand) the previous colour remains. To create sharp edges or straight lines,

artists often use masking tape. This can be applied, painted over and then removed to create straight edges. Here John Barber cuts out shapes in a piece of clear plastic to create a stencil for lifting out sharp-edged areas of paint on a rock. All these masking techniques are highly flexible and can be applied in a wide range of painting scenarios.

WELSH RIVER SCENE

1.

First sketch the principal shapes of the picture in pencil. Include quite a detailed outline of the branch over the river. This sketch will act as a guide for applying the art masking fluid in the next stage.

Materials and Equipment

- SHEET OF ROUGH, 300 GSM WATERCOLOUR PAPER, STRETCHED (SEE P. 19) • PENCIL
- FLAT SOFT HAIR BRUSHES: ONE SMALL, ONE MEDIUM, ONE LARGE • OLD BRUSH
- WATERCOLOUR PAINTS: CERULEAN BLUE, ULTRAMARINE BLUE, COBALT BLUE, BURNT SIENNA, YELLOW OCHRE, VIRIDIAN GREEN, PAYNE'S GREY, IVORY BLACK • ART MASKING FLUID • KITCHEN PAPER
- SCALPEL • SHEET OF THIN, CLEAR PLASTIC (OVERHEAD PROJECTOR SHEET) • CRAYON

2.

Use a small, old brush to apply the art masking fluid to the painting. Shake the bottle before you start. Paint the fluid onto the paper over the areas that you want to appear white in the final picture. Remember that you can always paint over areas if you put too much down – but not vice versa. Fill in the branch, the white water of the rapids and some dappled areas of foam. If you miss areas, do not go over the masking fluid again until it is dry – this usually takes about five minutes. Allow all the masking fluid to dry before continuing with the painting.

3.

Mix viridian, yellow ochre and Payne's grey. Now use a large flat brush to apply a wash of this colour to the area above the horizon of the water. Load the brush well with paint so that you can make the application in one go. As the paint passes over the masking fluid it will form into small droplets. These should be allowed to dry before the fluid is removed. Allow the brush to dry slightly. Apply it lightly over the area below the horizon. As the bristles pass over the bumpy surface of the paper, the paint will miss patches of paper. This should create the dappled effect of distant water.

4.

Now mix a dark colour using black, cobalt blue and burnt sienna. Then a green with viridian and ultramarine. Apply the first wash to the rest of the picture. Now add areas of the green into the wet paint.

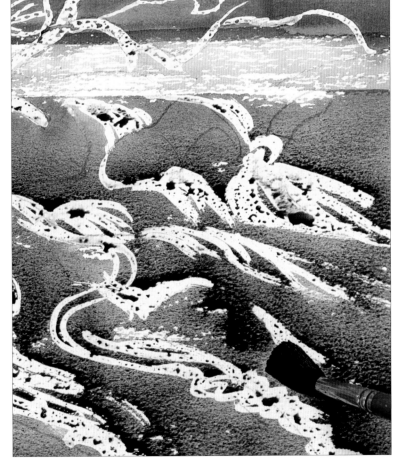

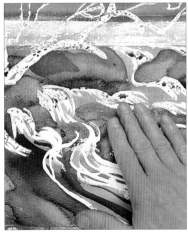

5.

Add some yellow ochre to the green wash. Use this to establish the rock shapes. Add black for some dark areas in the water. Allow the paint to dry, then rub off the masking fluid.

6.

The white areas that remain are too strong as they stand. Use a wet brush without paint to introduce some of the background colour to the white areas. Leave only the areas that you want to remain completely white. The background colour will not completely cover up the white areas – they will continue to show up as lighter areas. In the end probably only about 10 per cent of the white areas that you created with the masking fluid will remain untouched in the picture. This is why, as mentioned earlier, you can start with more white areas than you will actually need.

7.

The next stage is to create some highlights on the rocks. Do this with a clean, damp brush (without any paint). Rub the paper gently with the brush and some of the paint should lift off, creating the impression of light falling on the rocks.

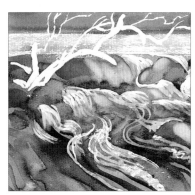

8.

Apply some cerulean blue to the river and across the upper water area. Now mix yellow ochre with a little Payne's grey and colour the branch – leaving white highlights.

9.

Define the rocks with thin lines of viridian, black and burnt sienna mix. Now add a rock to the lower left corner in black and viridian. Allow this to dry. Place a piece of thin, clear plastic over the rock. Using a pencil or crayon, draw some sharp-edged shapes onto the plastic where you want highlights on the rock. Also draw the outline of the rock.

10.

Remove the plastic from the painting. Using a scalpel, cut out the shapes in the plastic. You will then be left with a custom-made stencil with which to create highlights on the foreground rock.

11.

Place the stencil over the rock in the same position as it was when you drew the pencil marks. Use wet kitchen paper to lift off the paint under the stencil, keeping the stencil firmly in place. Dab down rather than from side to side to avoid water running under the stencil. Remove the stencil when the paint has lifted.

12.

Now add a weak wash of yellow ochre to the rock to warm the colour a little. Finally, use the point of a scalpel to scratch off small flecks of paint and expose the white paper below. Do this around the base of some of the rocks and in the rapids to create bubbling water.

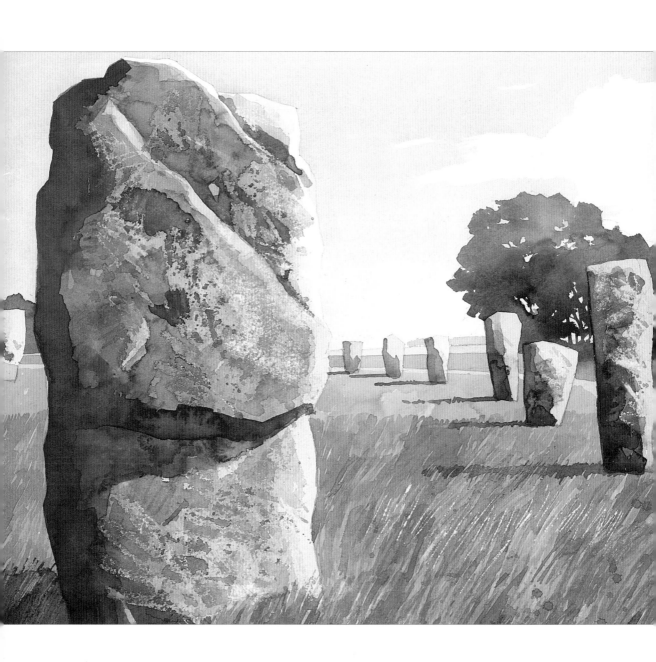

Technique

5

RESIST AND SGRAFFITO

This powerful scene has been painted using a number of techniques for creating texture. I have used candle wax on the paper to resist paint layered over it. The result mimics the rough texture of the ancient rocks, covered in lichen and weather-worn. I have also used sgraffito (scratching with a sharp point) to lift out areas of white paper in the grass. I worked by gradually layering up darker colours, allowing the textures to build as the painting progresses. The combined effect is a series of different planes of colour and texture, increasing the visual impact of the whole picture.

Ian Sidaway
Avebury Stone Circle
55 x 75cm (22 x 30in)

Resist and Sgraffito Technique

For the watercolour artist the term resist is usually reserved for the use of wax. When wax is rubbed onto paper it repels watercolour. This results in a dappled effect, the coarseness of the effect depending on the grain of the paper. This technique is particularly effective for representing rocks, cliffs, pebble beaches, ploughed fields or the bark on trees. Sgraffito, the other technique used here, comes from the Italian *graffiare* (to scratch). This involves using a sharp point or abrasive surface to scratch up white paper. The term also applies to the technique of mixing Gum Arabic to paint and then using a fine point to clear away lines of paint. Both techniques create highlights – and are used here to mimic light falling on uneven surfaces.

STONE CIRCLE

Left: For reference I used a pencil drawing from my sketch book, made on location. The site is the impressive stone circle of Avebury in southern England, a few miles away from the smaller, but more well-known, Stonehenge. The stones have become intricately textured – perfect subjects for resist technique.

Materials and Equipment

- SHEET OF ROUGH, 600 LBS WATERCOLOUR PAPER, STRETCHED (SEE P. 19) • PENCIL
- FLAT SOFT HAIR BRUSHES: ONE SMALL, ONE MEDIUM
- WATERCOLOUR PAINTS: CERULEAN BLUE, ULTRAMARINE BLUE, BURNT SIENNA, BURNT UMBER, YELLOW OCHRE, SAP GREEN, PAYNE'S GREY • GUM ARABIC • PALETTE KNIFE • CRAFT KNIFE OR SCALPEL • WHITE WAX CANDLE • KITCHEN PAPER TO CATCH MISTAKES

1.

First make a pencil sketch of the principal outlines in the picture. Now use a cerulean blue and ultramarine blue wash for the sky, leaving white areas for clouds. Allow this wash to dry before continuing. Now mix yellow ochre, burnt sienna and Payne's grey. Use a weak wash of this to colour the stones, leaving blank areas for white highlights. Start at the top of the stones and bring the paint down – this allows for far more accurate placing of the paint. The aim is to try to keep the paint within the boundaries of the stones, making a sharp edge.

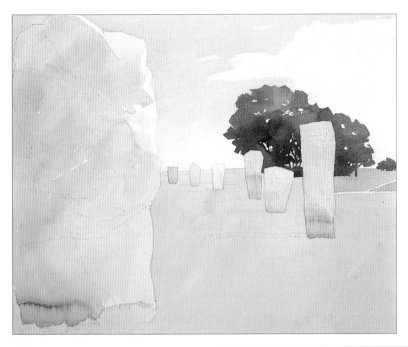

2.

Now make a slightly stronger wash of the same colour and put another layer on the stones – again leaving highlight areas and not covering the previous wash entirely. Mix sap green and yellow ochre for the first wash over the grass. Leave white areas for the chalk paths. Allow this to dry. Mix sap green and burnt umber for the trees. Leave blank areas for the gaps in the foliage as well as the gaps around the trunks. All the main elements of the picture have now received their first application of paint.

3.

Use a diluted wash of the tree mix to paint in the darkened hillside in the middle distance – leaving the paths white. Mix sap green with a little yellow ochre for the grass and apply it with the flat edge of the brush – using the paper texture.

4.

Now is the time for the first use of wax resist. Use a clear candle to rub wax onto the foreground stones. Rub it into areas that you want to attain a dappled effect. Also draw almost parallel lines of wax. As subsequent layers of paint are applied the wax will allow the lighter layers of paint to show through.

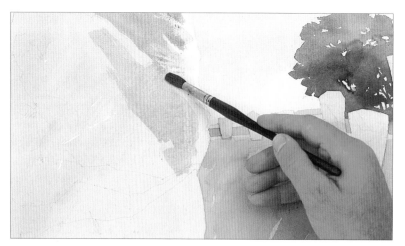

5.

Mix a darker stone wash with Payne's grey and burnt umber. Apply this to the stones – leaving highlight areas. As the colours get darker, they are applied to smaller areas of the stones. The stones reduce in detail as they recede. The most distant ones need only two different tones – light and dark.

6.

Continue to work up the texture of the stones. Gradually apply stronger greys, until eventually adding the final dark shadow areas. Reserve the very darkest colours for the rock in the foreground – this will add to the sense of distance in the work. As well as wax resist, there are other means of creating texture on the rocks. Allowing the darker colours to backrun slightly into the lighter colours gives an effective impression of lichen or moss on the rock. Also try spattering paint onto the paper – again adding to the rough texture of the stone.

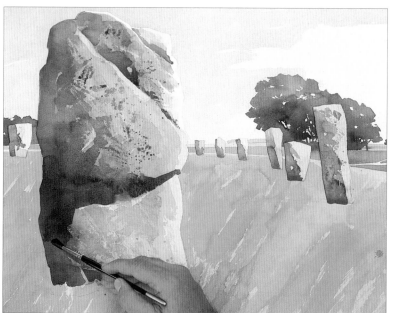

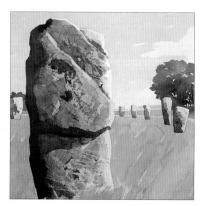

7.

Now step back and take a look at the picture. Most of the definition on the rocks should be complete. However the stones still look as if they are floating above the ground – so the next stage will be to add shadows. These will "ground" the stones, giving the desired impression of weight and solidity. Before this, however, the foreground grass needs some added texture.

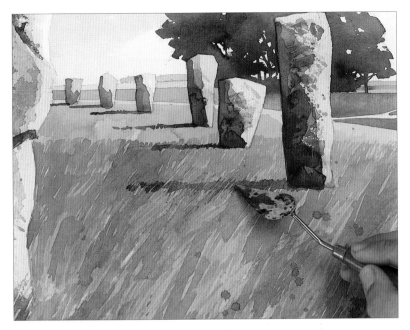

8.

Mix a wash of sap green, yellow ochre and burnt umber. Then use a thin brush in rapid strokes to create the impression of tall grass in the foreground. Allow this to dry. Now mix sap green, Payne's grey and burnt umber with Gum Arabic. Use this for the rock shadows. For the shadows that fall on the tall grass, run a fine edge (such as a palette knife) back and forward through the wet paint. This will create the impression of rippling shadows.

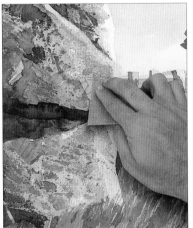

9.

The picture is now complete apart from some finishing touches. Use a piece of coarse sand paper to rub off some paint on the two nearest stones. This will create dappled highlights and enhance the texture.

10.

Now use a sharp edge such as a craft knife or a scalpel to scratch a series of parallel lines into the tall grass area. Exposing the white of the paper underneath creates effective highlights – giving the impression of sunlight striking the individual stalks of grass. The angle of the lines should match the surrounding grass – enhancing the illusion of a stiff breeze.

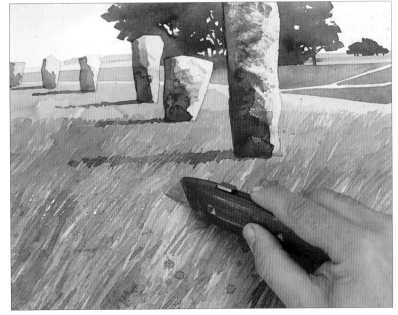

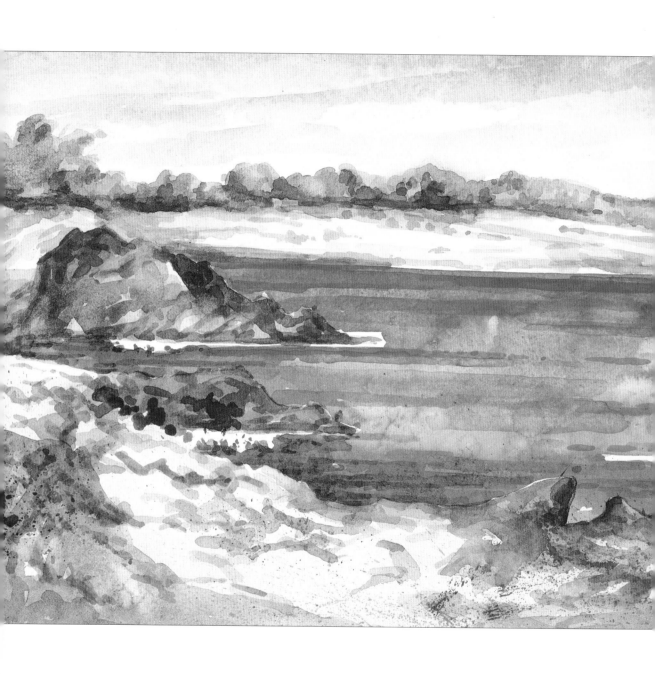

SPATTERING AND ROCK SALT

This lively painting captures the freshness of the Mediterranean in springtime. Although the sea is calm, it is not as placid as it is in summer. The artist, James Horton, uses spattering and rock salt to capture the movement of the water – as it meets the rocky shore and as it enters the bay. He also uses the two techniques to enhance the texture of the rocky beach, creating the impression of ragged rocks and scattered pebbles. James' style is liberal and brisk, which creates an immediacy in the image that a more laboured work would not capture. This style also suits on-location painting.

James Horton
Mediterranean Coast
30 x 40cm (12 x 16in)

Spattering and Rock Salt Technique

Flicking paint onto the paper is known as spattering and is a useful technique to liven up flat washes and to create textural effects. Hold the damp (not sodden) brush flat over the work and tap the brush gently to release the paint. More control can be achieved by using a stiff bristle brush such as a toothbrush: pull your thumb over the bristles and allow them to spring forward again. Spattering onto dry and wet paper creates different effects – so try experimenting first to make sure you use the right combination. Another technique used here is the application of rock salt. When this is applied to wet paint, it soaks up the surrounding moisture, creating a dappled effect. This is handy for suggesting uneven surfaces.

MEDITERRANEAN COAST

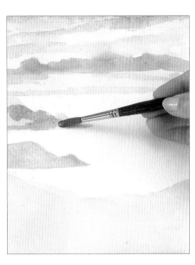

1.

Wash in the sky with ultramarine, cobalt blue and alizarin crimson. Use yellow ochre for the distant shore. Add cobalt and vermillion for the two outcrops. Now add cadmium red for the foreground. Mix alizarin crimson, ultramarine, and vermillion for the outcrops. Mix lemon yellow and oxide of chromium for the trees and add ultramarine and yellow ochre for the dark areas in the trees. Use vermillion, cadmium red, and lemon yellow to make dark areas on the distant shore. Add cobalt blue to the sky, and use burnt umber to darken the distant outcrop.

Materials and Equipment

- SHEET OF ROUGH, 450 LBS WATERCOLOUR PAPER, STRETCHED (SEE P. 19) • FLAT, SOFT HAIR BRUSHES: ONE MEDIUM, ONE SMALL
- WATERCOLOUR PAINTS: ULTRAMARINE BLUE, COBALT BLUE, PRUSSIAN BLUE, SCARLET LAKE, ALIZARIN CRIMSON, VERMILLION, CADMIUM RED, CADMIUM ORANGE, BURNT UMBER, BURNT SIENNA, OXIDE OF CHROMIUM, YELLOW OCHRE, LEMON YELLOW, PAYNE'S GREY
- ROCK SALT • KITCHEN PAPER TO CATCH MISTAKES

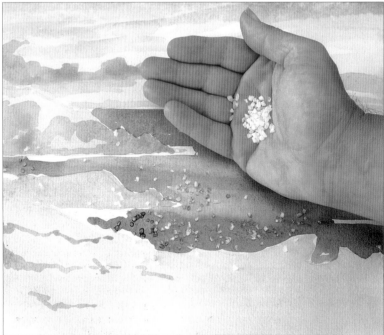

2.

Mix vermillion and burnt umber and mark in lines on the near beach. Now mix two washes for the sea: first ultramarine blue and alizarin crimson, and second Prussian blue and cadmium orange. Use the first wash for the distant water and the second in the foreground. Save some of these colours for later. While the sea paint is still wet, sprinkle some rock salt crystals over the area. Leave these in place to take effect while you continue working on other areas.

3.

Using rock salt can be a hit-and-miss affair. Try to scatter the salt so that it is spread evenly over the area that you want the dappled effect to appear on. Break up clumps of crystals. Leave the crystals in place until they are completely dry. This technique is best used indoors – where the salt will not be blown around in the wind.

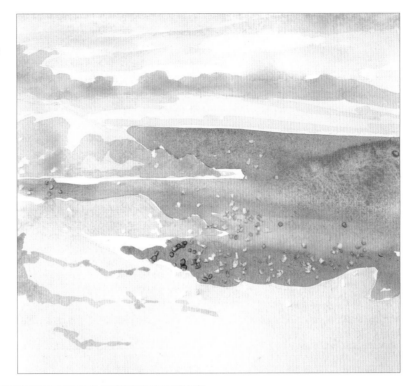

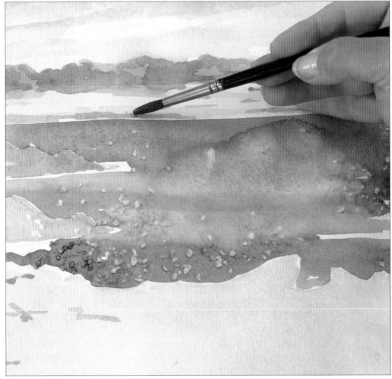

4.

While the rock salt is drying, apply some oxide of chromium into the distant trees. Now mix burnt umber and vermillion and use this to mark in more dark areas on the distant shore. Add some oxide of chromium to some of the distant sea mixture for shade in the trees. Now add scarlet lake to this mixture to mark dark tones on the far outcrop.

5.
Use burnt umber to add darker tones to the nearer outcrop. Use this colour to outline the shore line on the right. Now use burnt sienna to add to the lines on the foreground. Do the same with Payne's grey, and then cadmium red to add another tone. These lines should gradually build to give the impression of the rocks on the beach – but do not overdo it. Now the rock salt should be ready to be removed – check that it is dry. Shake the crystals off into a dustbin. Use some of the sea wash saved from earlier to go over the sea again – to integrate the dappled effect of the salt.

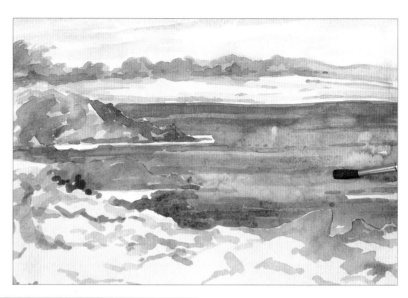

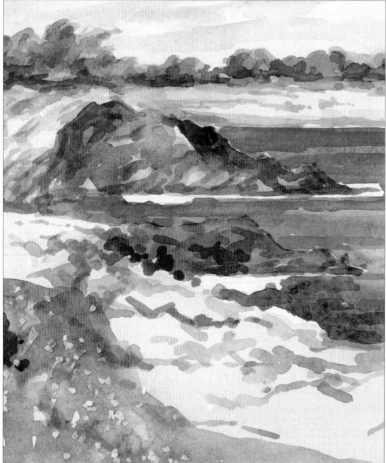

6.
Now use alizarin crimson and vermillion to paint a dark rock into the left corner of the picture. Again, add salt to the wet paint and leave the crystals in place to dry. Use oxide of chromium and a little cobalt blue for more dark areas in the trees. Use alizarin crimson and ultramarine blue mix for the dark areas on the far outcrop.

7.

When it has dried, remove the rock salt from the rock. Mix some vermillion and cadmium orange together and add touches of this into the rock. Now use some alizarin crimson and ultramarine blue for the dark areas in the sea.

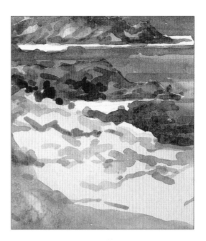

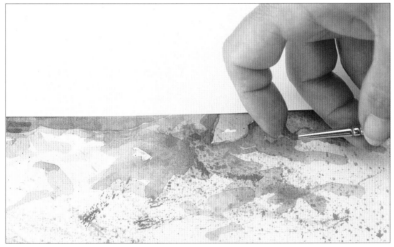

8.

Make a mixture of burnt umber, yellow ochre and vermillion and load it onto a small brush. Now cover the sea area of the painting with a piece of paper for protection. You can now spatter the beach area without getting paint onto the sea.

9.

Mix ultramarine blue and scarlet lake to mark some darker areas onto the shore. Use a dark colour to add some definition into the trees. Finish off the sea with the washes used earlier, adding in wave lines. Now load a small brush with ultramarine blue and spatter some spray where the waves hit the shore.

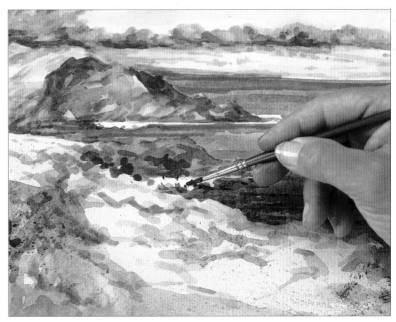

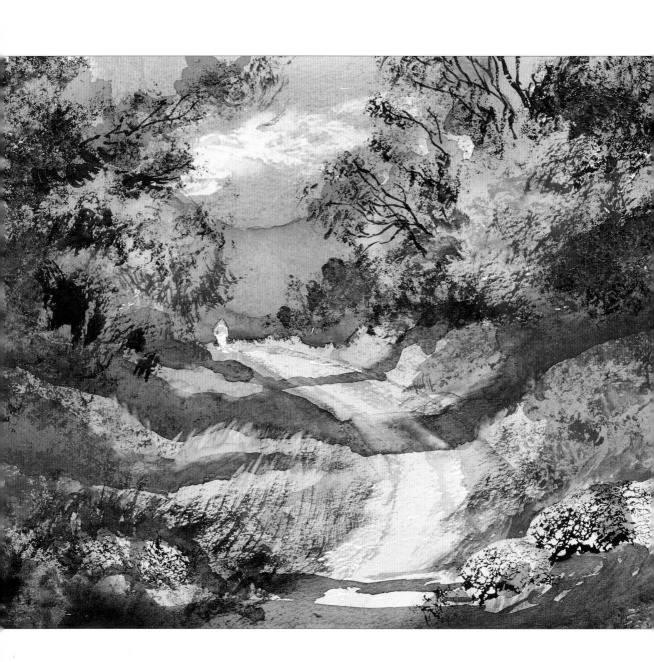

Technique
7

DRY BRUSH AND SPONGES

In this work the artist demonstrates a masterly command of two different techniques. He uses both dry brushes and sponges to create the impression of leaves, ground foliage and rocks. In his careful use of colour and shading, John Barber has also managed to convey the low, crisp light of a fine autumn day. The path with the figure just about to disappear from view adds to the sense of a moment in time captured and preserved – reflecting the fact that the leaves are soon to fall and winter is on the way. This is a fine example of how a painting can trigger an emotional response in the viewer.

John Barber
Autumn Woods
30 x 40cm (12 x 16in)

Dry Brush and Sponges Technique

When a brush that is barely damp is dragged across the paper surface the bare minimum of paint is deposited. Far from leaving a solid mark, lines from the individual bristles can be seen. The technique is perfect for creating the impression of grass, rocks, bark or the grain of wood. The brush needs to be fanned out before being applied so that each bristle can make its mark. Sponges are a useful tool for the water-colour artist. When used as a stencil to dab colour onto a surface, they leave the impression of their intricate forms. Natural sponges have a more organic, irregular form, while artificial sponges are more regular. They can be used to effect a range of natural forms, including tree shapes, storm clouds and rock surfaces.

Autumn Wood

1.

Make a pencil sketch. Wash in the sky with ultramarine, bringing the paint down below the level of the trees. Lift out cloud shapes with kitchen paper. Allow this to dry. Add viridian and burnt sienna to the sky wash for the centre area. Leave a white shape for the figure. Use this colour for the overhanging tree on the left and for the far right area.

Materials and Equipment

• SHEET OF ROUGH, 300 GSM WATERCOLOUR PAPER, STRETCHED (SEE P. 19) • PENCIL • FLAT SOFT HAIR BRUSHES: ONE SMALL BRUSH FOR DETAIL, ONE MEDIUM BRUSH, ONE LARGE BRUSH FOR WASHES • WATERCOLOUR PAINTS: ULTRAMARINE BLUE, BURNT SIENNA, VERMILLION, YELLOW OCHRE, SAP GREEN, VIRIDIAN GREEN, IVORY BLACK • KITCHEN PAPER • ARTIFICIAL SPONGE • NATURAL SPONGE

2.

Add burnt sienna for a lighter green to the right of the centre. Add yellow ochre and viridian for the golden trees. Use a light wash of this for the grass area on the right, then add a darker area with burnt sienna. Use the same light wash for the grass on the left. Paint the path with yellow ochre. Mix sap green with a little burnt sienna for the grass along the right edge of the path and darken this slightly for the left side. Use yellow ochre with sap green for the lower left corner.

3▸

Use yellow ochre for the bright foliage to the right of the figure. Now mix yellow ochre and burnt sienna for the ferns on the left. Add viridian into the yellow ochre for the green in the near foreground. Paint the shadows with alizarin crimson, ivory black and ultramarine mixture.

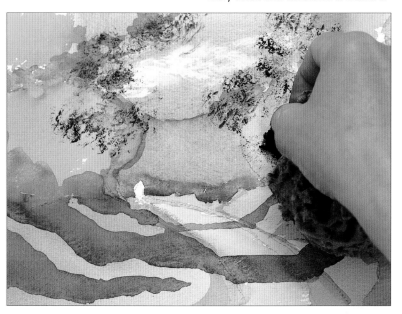

4◂

Allow the shadows to dry. Mix viridian green, burnt sienna and ultramarine. Apply this colour to the trees with a natural sponge, rotating the head so as not to repeat patterns. Use this colour for the lower foreground foliage as well.

5▸

Change the sponge colour to burnt sienna, cadmium yellow and a little ultramarine. Use this to add foliage to the bright golden trees. Now use just burnt sienna and a little ultramarine for the ferns and the nearest branches of the golden trees. Use a damp, clean brush to lighten the shadow areas.

6.

Now paint the branches of the trees with a small brush. Use a mix of burnt sienna and a touch of ivory black and keep the brush quite dry – to make the paint more controllable.

7.

Use the dry brush technique to add more foliage detail. Mix viridian and ivory black for the dark foliage on the left. Drag the brush so that paint picks up the texture of the paper. Now use burnt sienna for the golden foliage.

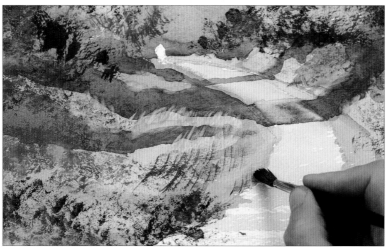

8.

Now work on the grass. Mix viridian and burnt sienna. Be sure to use the brush fanned open so that it makes a series of fine lines when applied. Drag the brush lightly over the surface. This will create the impression of tall grass.

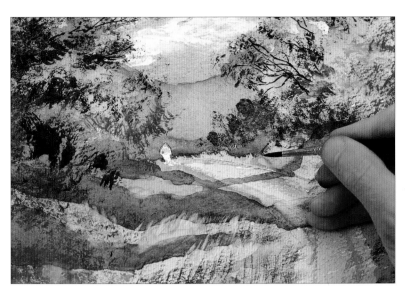

9.

Add texture to the path with some ultramarine and black applied lightly. Use a fine brush to paint the figure in a mix of vermillion and burnt sienna. Edge in the foliage around the figure to define its shape. Use a small, damp brush without paint to break up the line between the bright and dark areas to the right of the figure.

10.

For another texture, use a wet sponge to rub out an area in the right and left foreground. Dry the area with kitchen paper and allow the space to dry.

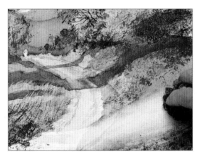

11.

Use an artificial sponge to apply a black and viridian mix. This creates the impression of a mossy rock. Use the same colour with some ultramarine for shadows on the rocks, and viridian and burnt sienna for grass around them. Finally, use ultramarine and black to wash in some foreground shadows.

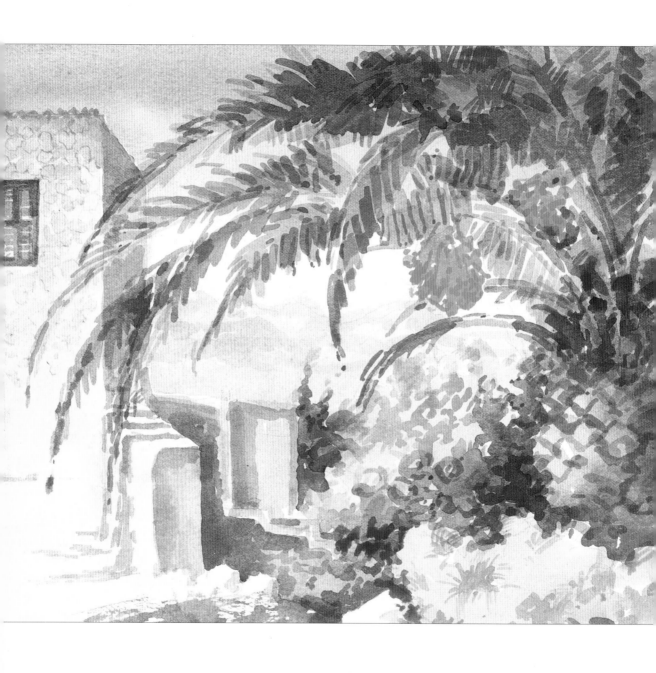

S CUMBLING AND B ACKRUNS

A peaceful moment in the garden of a Mediterranean villa. In this work, James Horton manages to capture the light of a hot summer day falling on the dense foliage of a lush garden. He uses scumbling to achieve the impression of delicate shade forms, and backruns to add to the sense of thick foliage and shade. The result is an effective combination of bright and dark areas, enhancing the impression of heat by the contrast with cool spots. James gradually builds up stronger colours as he works, which helps to create the impression of depth in the foliage. The distant mountains carry the eye back and give a sense of space to the work.

James Horton
The Villa
30 x 40cm (12 x 16in)

Scumbling and Backruns Technique

The intention of scumbling is to create an area of broken colour. This is not achieved by flooding the surface with a wet wash, but by scrubbing fairly dry paint over the surface. The paint then picks up the texture of the paper. It is best to use an old brush as the scrubbing action can damage the bristles. The texture of the paper is important to the technique, and it is better to use rougher surfaces rather than smooth ones. Backruns, also known as backwashes or watermarks, happen when paint is added to a wet area of colour. They often happen by accident and can be a nuisance if they appear where they are not wanted. They are used especially for enhancing stormy skies or seas. Experiment with the effect before you use it.

THE VILLA

1.

Use ultramarine, Prussian blue and scarlet lake for the sky and darken this for the hills. Blot out an area for the foliage. Add lemon yellow and scarlet lake for the villa's dark side. Add raw sienna for the dark wall. Mix vermillion, cadmium red and raw sienna for the villa's light side.

Materials and Equipment

- SHEET OF NOT, 140 LBS WATERCOLOUR PAPER, STRETCHED (SEE P. 19) • SOFT HAIR BRUSHES: ONE MEDIUM, ONE SMALL • OLD BRUSH FOR SCUMBLING • WATERCOLOUR PAINTS: ULTRAMARINE BLUE, PRUSSIAN BLUE, COBALT BLUE, SCARLET LAKE, ALIZARIN CRIMSON, RAW SIENNA, CADMIUM RED, VERMILLION, BURNT UMBER, LEMON YELLOW, YELLOW OCHRE, INDIAN YELLOW, OXIDE OF CHROMIUM, PAYNE'S GREY • KITCHEN PAPER

2.

Mix oxide of chromium and Prussian blue for the upper palm branches, using a small brush to achieve the jagged impression of the palm. Use vermillion and a little yellow ochre for the palm fruit. Use a small brush again to line in the woody part of the palm branches with a yellow ochre and oxide of chromium mix. Mix more oxide of chromium into this to add the actual fronds. Add more Prussian blue for the darker branches. Mix ultramarine blue and scarlet lake for the trunk of the palm, adding vermillion for the brighter left side – allow this to backrun.

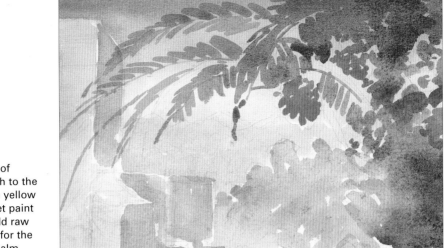

3.

Mix yellow ochre and oxide of chromium for the green bush to the left of the palm. Allow some yellow ochre to backrun into the wet paint to create a soft highlight. Add raw sienna to the original green for the brown bush in front of the palm.

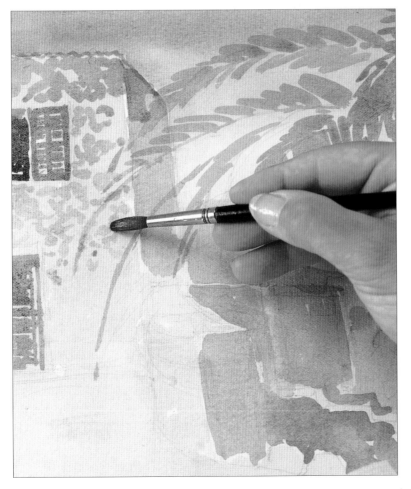

4.

Mark in the shutters in a dark green made up of Prussian blue and oxide of chromium. Fill in the dark interior of the windows with scarlet lake and Payne's grey. Use Indian yellow and vermillion for the roof tiles and for the top of the windows. Make a lighter wash of the shadow mixture for the dappled stones on the villa.

5 ▸

Use the shadow mix to add a darker tone to the dark side of the villa. Mix a very light wash of this for the pale shadow at the bottom right of the front of the villa. Mix more vermillion to the roof tile mixture for the thin band of light near the garden wall. Now use a pencil to circle in and define the dappled stone effect on the villa.

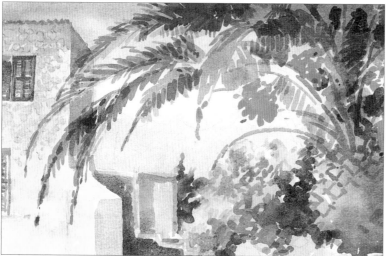

6 ◂

Add a darker green to the shutters for definition. Do the same for the palm branches, using a dark green of lemon yellow and burnt umber. Mark in the crisscross pattern of the trunk with scarlet lake and Prussian blue. Add darker colours to the foliage in general to create depth. Use a dark green to mark in the tree at the bottom of the garden. Also, add darker tones to the shadows.

7 ▸

Make a shadow mix of scarlet lake and cobalt blue. Use a light version of this for the shadow of the palm branches falling over the wall. Follow the contours of the wall. Add more cobalt blue to make the shadow in the centre foreground. Use the brush quite dry and scumble the paint so that it picks up the texture of the paper. Use some of the dark foliage green to mark in dark areas on the end of the wall.

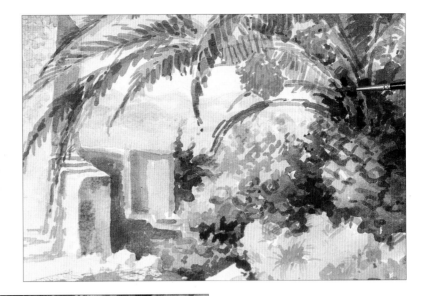

8.

Use vermillion and a little oxide of chromium to make a brown for the grasses in the foreground. Use Payne's grey for the dark patches in the foliage.

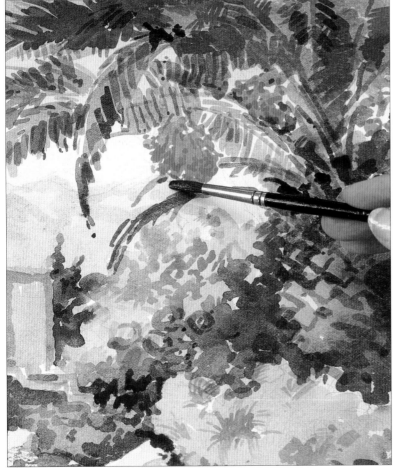

9.

Add cadmium red and yellow ochre mix to the palm fruit. Use burnt umber and oxide of chromium to strengthen the branches. Use cobalt blue for the shadowy parts of the palm branches, and to enhance the crisscross trunk pattern. Now touch in the mountains with a mix of ultramarine blue and a little alizarin crimson. Add some Payne's grey to this to strengthen the windows. Finally, use this colour to strengthen the shadows generally.

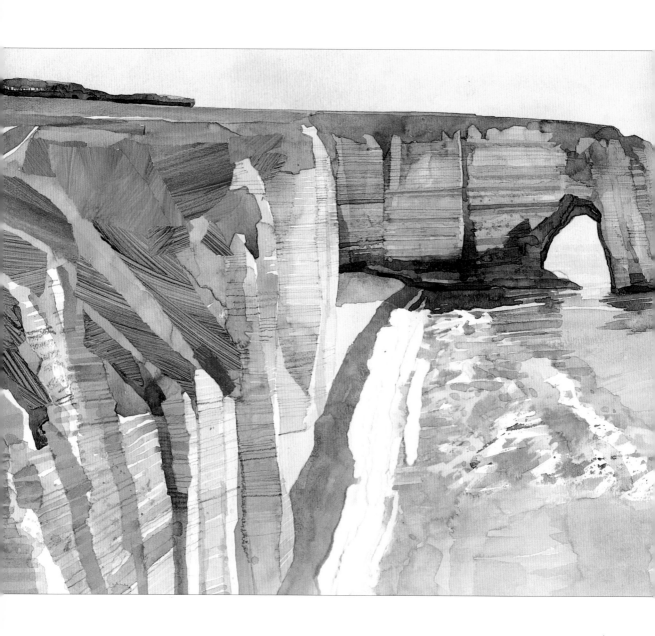

Technique

9

A STEP FURTHER

This final project shows how to use various techniques and incorporates something a little bit different: collage. Although traditionalists may baulk at the idea of including such a technique in a painting, collage can be used to achieve unique textural effects. As this project demonstrates, the use of collage really brings the whole painting to life, adding another dimension to this depiction of cliffs in Normandy, northern France. The painting is on a large scale, allowing room for other techniques as well as collage, including the use of masking fluid and spattering. The natural drama of the scene is conveyed with suitable vigour.

Ian Sidaway
Cliffs, Etretat
58 x 76cm (23 x 30in)

Collage Technique

Incorporating collage into a watercolour painting involves using pieces of coloured or plain paper to add texture to areas of the picture. The paper is applied after the majority of the actual brush work has been completed. As you get more familiar with the technique, you can build up a reserve of paper specifically for use as collage material. You can also create collage material by painting sheets of paper in greens, browns, blacks and greys. Use a large DIY-type brush so that paint dries in interesting lines of variegated colour. The paper should be torn so that it leaves a slightly ragged edge – this will allow it to blend into the picture. Position the collage material on the picture first, before using spray glue to fix it in place.

CLIFFS, ETRETAT

Left: I used a mixture of references. Photographs help to recall colours and textures, while the pencil study records the structural details of the cliff and the beach.

Materials and Equipment

• SHEET OF NOT, 400 LBS WATERCOLOUR PAPER, STRETCHED (SEE P. 19) • MEDIUM BRUSH FOR WASHES, SMALL BRUSH FOR DETAIL
• WATERCOLOUR PAINTS: CERULEAN BLUE, ULTRAMARINE BLUE, MADDER ALIZARIN, BURNT UMBER, BURNT SIENNA, YELLOW OCHRE, BURNT OCHRE, CADMIUM YELLOW, CADMIUM YELLOW LIGHT, LEMON YELLOW, SAP GREEN, PAYNE'S GREY
• SCRAP PAPER IN DIFFERENT COLOURS FOR COLLAGE • PAPER GLUE • GRAPHITE PENCIL
• ARTIST'S MASKING FLUID

1.

Having completed the initial pencil sketch, use masking fluid where the white of the paper will represent the surf on the shore. Now use a light wash of Payne's grey, yellow ochre and burnt ochre for the cliffs. Add some Madder alizarin for the beach. The sky wash consists of cerulean blue, ultramarine blue and a little cadmium yellow. Strengthen with more blues and some cadmium yellow light for the sea. Make sure that the masking fluid is dry before applying the wash.

2▸

Using a smaller brush, fill in the dark green areas of the clifftop wood with a mixture of sap green, Payne's grey and burnt umber. Leave a thin strip of light below the foliage, and mark in the trunks of the trees with the same dark green mixture. Add sap green and lemon yellow to the mixture to paint in the lighter grass areas. Make a darker green with sap green, yellow ochre and a little burnt umber for the dark areas on the clifftop grass. Allow the colour to run to the edge of the painted area, as this will create an effective darkening towards the foreground.

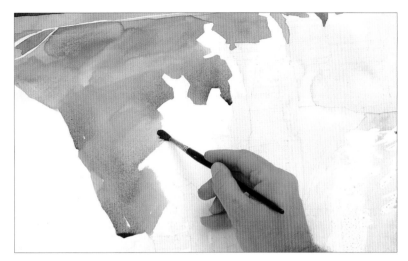

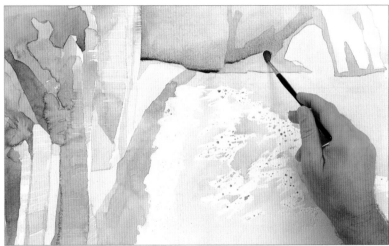

3◂

Add shading to the woods with sap green, Payne's grey and burnt umber. Mix a little burnt umber to the cliff wash and mark in the sand area of the beach. Add some Payne's grey for the darker cliff area in the distance. Use fingertips to rub off the masking fluid.

4▸

Now add some burnt ochre to the cliff mixture for the detail and shadow on the cliff. Use a lighter version (by adding more water) for the shadow on the beach.

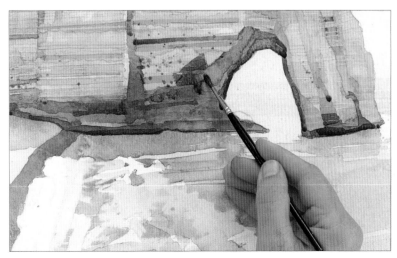

5.

Now that the majority of the brush work is complete, it is time to start introducing the collage materials to the picture. Rip some long pieces of blank paper for the surf on the beach. Position the paper on the painting before glueing it. Lay the torn paper so that the exposed interior along the edges is uppermost. This will give a fine textural effect. Overlap the strips slightly to give the impression of water ebbing and flowing. Now use some grey-brown paper for the cliffs, small strips for above the arch, larger pieces for the foreground. Once the cliff paper is fixed, blend it in by spattering the area with the cliff wash. This will also add texture.

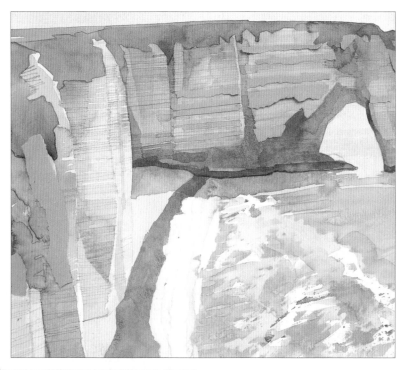

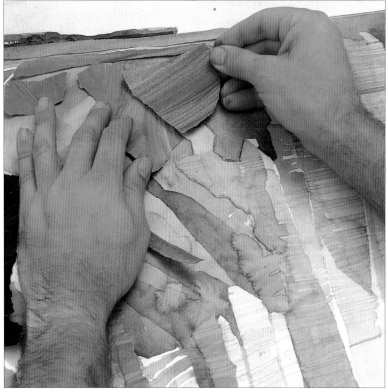

6.

Now use some painted green paper for the grass areas above the cliff. Different shapes and shades of green will help the overall impression. Again, spend some time trying different positions before you finally fix the paper on with glue.

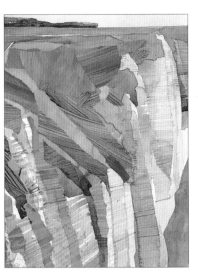

7.

Once in place, the collage should create the impression of different areas of grass and light, and give an impression of the underlying contours of the cliffs themselves.

8.

Use a dark green (sap green, Payne's grey and burnt umber) to paint in the edges of the green paper – this will help it to blend in. Use a graphite pencil to mark in the strata lines on the cliff. The different orientations of the lines will help to describe the shape of the cliffs.

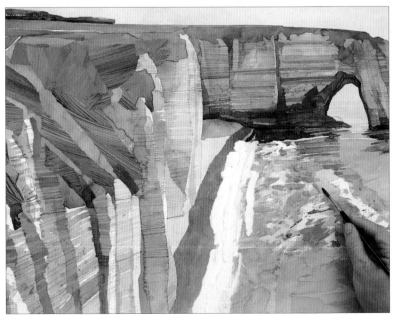

9.

Mark in the dark shadow area under the arch with a mix of ultramarine and cerulean blue, Payne's grey and a little lemon yellow. Use a lighter version of the same mixture as the reflection comes closer.

INDEX

PICTURE CREDITS
The author and publishers would like
to thank **The Bridgeman Art Library**,
London for permission to reproduce
additional photographs:

page 6 (Victoria & Albert Museum, London),
page 7 (British Museum, London),
page 8 (The Barber Institute of Fine Arts,
University of Birmingham),
page 9 (Agnew & Sons, London)